少兒八段錦

Ba Duan Jin for Children

胡曉飛　等 編著

Edited by Hu Xiaofei and others

U0152282

编写人员名单
List of Editor and writer

胡曉飛 Hu Xiaofei	王潤東 Wang Rundong
彭翔吉 Peng Xiangji	範高盛 Fan Gaosheng
冷傳奇 Leng Zhuanqi	房　輝 Fang Hui
韓曉明 Han Xiaoming	徐景福 Xu Jingfu
龔明俊 Gong Mingjun	黃美蓮（古巴）
胡　婷 Hu Ting	孫克忠 Sun Kezhong
楊　帥 Yang Shuai	方丈澤 Fang Zhangze

翻譯：Chloe Wong（黃倚晴）

目　录　Content

前 言 Introduction ..**04**

序 Preface ...**08**

第一章　少兒八段錦概述
Chapter One　Overview of Ba Duan Jin for Children

第一節　概念及簡介 ...12
Concept and Brief Introduction

第二節　創編意義和原則 ...16
Meanings and Principles of Creation

第三節 作用原理及風格特點 ...20
The Working Principle of Ba Duan Jin for Children

第二章　少兒八段錦歌訣和釋義
Chapter Two　Songs and Interpretation of Ba Duan Jin for Children

第一節　少兒八段錦全版歌訣 ..30
Section One　Full Version Songs of Ba Duan Jin for Children

第二節　少兒八段錦歌訣釋義 ..33
Section Two　Interpretation of Ba Duan Jin for Children

第三章　少兒八段錦基礎
Chapter Three　Basic Techniques of Ba Duan Jin for Children

第一節　基本手型 ..52
Section One　Basic Hand Forms

第二節　基本步型 ..56
Section Two　Basic Stance Forms

第四章　少兒八段錦站勢套路
Chapter Four　Standing Routine of Ba Duan Jin for Children

起勢 .. 63
Starting Form

第一式　兩手托天理三焦 .. 66
 (Movement One)Holding the Hands High with Palms Up to Regulate the Internal Organs

第二式　五勞七傷往後瞧 .. 70
 (Movement Two)Looking Backwards to Prevent Sickness and Strain

第三式　調理脾胃須單舉 .. 74
 (Movement Three)Holding One Arm Aloft to Regulate the Functions of the Spleen and Stomach

第四式　左右開弓似射雕 .. 78
 (Movement Four)Posing as an Archer Shooting Both Left- and Right-Handed

第五式　搖頭擺尾去心火 .. 82
(Movement Five)Swinging the Head and Lowering the Body to Relieve Stress

第六式　攢拳怒目增氣力 .. 87
(Movement Six)Thrusting the Fists and Making the Eyes Glare to Enhance Strength

第七式　雙手攀足固腎腰 .. 92
 (Movement Seven)Touching the Feet to Strengthen the Kidneys

第八式　背後七顛百病消 .. 96
(Movement Eight) Moving the Hands down the Back and legs, and Raising and Lowering the Heels to Cure Diseases

收勢 .. 101
Closing Form

前 言

八段锦是中国传统经典健身术之一，是我国传统健身文化的珍贵宝藏。千百年来，八段锦以其丰富的文化内涵、独特的风格形式、至简至易的运动特点，以及强健身心的显著效果，深受国内外大众的喜爱，成为迄今为止流传范围广、受众多、出版发行频繁的传统健身项目。

八段锦多次被列入"全民健身""体医融合"等国家重要计划之中，最近还被国家卫生健康委员会和国家中医药管理局纳入《新型冠状病毒肺炎恢复期中医康复指导建议（试行）》，可见其在传统健身术领域的显著地位。然而遗憾的是，遍寻国内外文献，尚未见到有关少年儿童的八段锦信息。众所周知，少年儿童是一个极其庞大的群体，据统计，14岁以下儿童，在我国有 2.6 亿，占人口总数的 18% 以上；在全球有 19.6 亿，占人口总数 25% 以上。针对少儿身心特点，面向孩子们推广八段锦，对于增强其体质、提高其身心健康具有重要意义。

我们在精研古现代八段锦的基础上，结合少儿身心特点和当前学校体育教学工作的实际需要，创编了这套《少儿八段锦》，填补了该领域的空白，增进了少年儿童的身心健康，落实了中医和武术进校园的国家战略。

《少儿八段锦》在沿用了八段锦的动作名称、动作数量和核心定势，继承了其简单大方、松紧结合、动静相间、中正安舒的练习特点的基础上，作了相应的创新。其一，针对少年儿童的身心特点和学校体育教学工作的实际需求，从动作招式、风格特点、练习强度、练习量和音乐选用上作出相应调整，使之呈现刚柔相济、活泼大方、欢快有趣的特点，使孩子喜欢学、愿意练，进而获得健身体、愉精神的效果，便于在中小学推广。其二，《少儿八段锦》针对学校体育活动开展的实际情况，设计不同练习时长和练习形式，使之既适用于室内外体育课的教学，又满足课间操、团体操表演和社团活动的需要。其三，《少儿八段锦》配以思想性强、文化底蕴深厚、中医知识丰富、格调清新、朗朗上口的歌诀，使孩子们可以边咏边练，在享受习练的过程中获得塑形强身、愉悦心情、陶冶情操和增长知识的效果，使《少儿八段锦》成为既有利于少年儿童身心健康的手段，又成为其增长知识、陶冶情操的良好载体和抓手。

　　可喜的是，《少兒八段錦》自 2019 年创编推广以来，受到了广大中外 小朋友、"大朋友"的热烈欢迎。许多中小学迅速将其用于课间操和中医社团活动中，一些著名武术学校将其作为团体操表演和对外展示项目；在 2020 年"新冠病毒"肆虐的时候，它也成为许多家长居家"训"娃的有效 手段，连"武状元"、武术世界冠军、摔跤世界冠军和健身气功世界冠军 都将其作为"宅家"期间"硬核"带娃的良方。在国外，许多老爷爷、老奶奶还将其作为健身培训课程的整理活动，使以往枯燥乏味的健身场所瞬 间成为欢快的孩童乐园。为此，《少兒八段錦》得到学习强国、新华网、 人民网、人民体育等国内各大媒体 APP 和公众号的报道和推荐。我们相信， 如假以时日，它将成为少年兒童普遍欢迎的健身手段。我们也会进一步完 善少兒八段锦练习体系，将研究开发的适合小朋友们学习的《少兒八段錦》 （卡通版）、《少兒八段錦持球练》和《坐势少兒八段錦》等书籍，以餐小 读者之需，为进一步改善少兒身心健康做出应有的贡献。

　　应该说明的是，由于我们水平有限，对中小学生体育现状的了解还需 进一步深入，加之时间仓促，书中不免会有一些疏漏或不当之处 ，敬请 各界人士不吝指正和批评，借此机会向大家表示感谢。

<div align="right">作者
2020 年 12 月</div>

Introduction

Ba Duan Jin is one of the classic Chinese traditional fitness techniques and is a precious treasure of my country's traditional fitness culture. For thousands of years, as Ba Duan Jin has been loved by people all around the world for its rich cultural connotation, unique style and form, simple and easy sports characteristics, and the remarkable effect of strengthening body and mind, it has become a traditional fitness program that has been widely spread, widely received, and frequently published so far.

Ba Duan Jin has been included in important national plans such as "National Fitness" and "Sports and Medical Integration" many times. It has recently been included in the " Rehabilitation Guidance Recommendations for Chinese Medicine during the Recovery Period of New Coronavirus Pneumonia (Trial)" by the National Health Commission and the State Administration of Traditional Chinese Medicine, showing its remarkable position in the field of traditional fitness techniques. However, it is a pity that after searching domestic and foreign documents, we haven't found any information about Ba Duan Jin for children. As we all know, children are an extremely large group. According to statistics, there are 260 million children under the age of 14 in China, accounting for more than 18% of the total population; in the world, there are 1.96 billion children, accounting for more than 25% of the total population. According to the physical and mental characteristics of children, the promotion of Ba Duan Jin to children is of great significance for strengthening their physical fitness and improving their physical and mental health.

Based on the intensive research on ancient and modern Ba Duan Jin, we combined the physical and mental characteristics of children and the actual needs of the current physical education work at schools, so as to create this set of "Ba Duan Jin for Children", which fills the gap in this field, enhances children's physical and mental health, and implements the national strategy of Chinese medicine and Wushu of entering the campus.

"Ba Duan Jin for Children" follows the action name, number of movements, and core set of Ba Duan Jin. Based on inheriting the characteristics of having simple and generous, loose and tight, dynamic and static, calm, impartial and comfortable combinations, corresponding innovations have been made. Firstly, according to the physical and mental characteristics of young children and the actual needs of school physical education work, corresponding adjustments are made in the movement styles, style characteristics, practice intensity, practice level and frequency, and the selection of music, so as to present the characteristics of rigid and soft, lively and generous, cheerful and interesting, so that children would like to learn and willing to practice, thereby obtaining the effect of fitness and spirit. As a result, it can be promoted in primary and secondary schools. Secondly, "Ba Duan Jin for Children" is designed for the actual situation of school sports activities. Different exercise durations and exercise forms make it suitable for both indoor and outdoor physical education teaching, and meets

the needs of inter-class exercises, group gymnastics performances and club activities. Thirdly, "Ba Duan Jin for Children" is equipped with a strong ideological, profound cultural background, rich knowledge of Chinese medicine, fresh style, and catchy songs, so that children can chant during practices, shape and strengthen their bodies while enjoying the practices. The effect of being happy, cultivating sentiment and increasing knowledge makes "Ba Duan Jin for Children" not only a means for the physical and mental health of children, but also a good carrier and grasping hand for increasing knowledge and cultivating sentiment.

Fortunately, "Ba Duan Jin for Children" has been warmly welcomed by Chinese and foreign children and adults since it was created and promoted in 2019. Many primary and secondary schools quickly use it in inter-class exercises and Chinese medicine club activities, and some famous Wushu schools use it as a group gymnastics performance and external display project; when the COVID-19 is raging in 2020, it has also become an effective means for many parents to train their kids at home, even "Wu Zhuangyuan" (successful scholars), world champion of Wushu, world champion of wrestling, and world champion of Health Qigong use it as a good "hard core" for their kids during the lockdown period. In foreign countries, many grandpas and grandmas use it as an activity for fitness training courses, making the previously boring fitness venues instantly become a cheerful paradise for children. Regarding this, "Ba Duan Jin for Children" has been reported and recommended by major domestic media apps and public official accounts such as Xuexiqiangguo, Xinhuanet, People's Daily Online, People's Sports, etc. We believe that it will gradually become a popular fitness method for children. We will also further improve the practice system of "Ba Duan Jin for Children", and will research and develop books such as cartoon version of "Ba Duan Jin for Children", "Practising Ba Duan Jin for Children with a Ball" and "Ba Duan Jin for Children with Sitting Posture", etc. We hope we can meet the needs of minority readers, and make due contributions to the further improvement of children's physical and mental health.

It should be noted that due to our limited level, we need to further understand the current situation of primary and secondary school students' physical sports education. In addition to the time constraints, there will inevitably be some omissions or improprieties in this book. People from all walks of life are welcome to correct and criticize. I would like to take this opportunity to thank you all.

Author

December 2020

序

聽到胡曉飛教授攜其博、碩學子所著的《少兒八段錦》一書即將出版 的消息，我心中充滿了喜悅，喜在中國武術運動、導引養生體系中又增添了一件珍寶。為此，我熱情地祝賀該書隆重問世。

胡曉飛教授是我國知名的導引養生學者，是海內外著名健身氣功理論家、實踐家，著作頗多，如《乾隆養生術》《強身健體八段錦》《輪椅 健身術》《體育養生功前熱身》及與我合著的《養生築基功》等。實踐證明， 這些著作對中華傳統文化、武術文化、導引文化的傳播和發展具有重要的開拓意義。

在我為此書作序感到興奮之時，突然想起了高年生先生在《德國兒童小說》之序中所說："古往今來，世界各國出版發行了浩如繁星、璀璨奪目 的優秀兒童作品，在各民族間交流、傳播，哺育了一代又一代少年兒童， 像《賣火柴的小女孩》《皇帝的新衣》《漁夫和金魚的故事》等著名童話， 都早已跨越了國家的界碑，沖破了時代的藩籬，成為各國兒童共有的精神財富。"

現在，胡曉飛教授采用編寫兒童讀物的經驗，使用歌謠形式創編了《少兒八段錦》，該書融知識性、思想性、實用性、娛樂性、趣味性及德、智、體、 美"四育"於一體，形象優美，簡單易學，語言生動，淺顯活潑，很適合 國內外小朋友學習，使之達到健身健體之目的。

總之，《少兒八段錦》一書，在我看來，字裏行間觀點新穎，飽含異彩， 拔高創新，是一部不可多得的武術導引健身著作。

胡曉飛教授邀我作序，我不揣冒昧，信筆成文。誠懇向廣大國內外少年兒童、家長及少兒事業工作者推薦讀書，希望大家喜歡！

北京體育大學教授
中國首位武術、健身氣功雙九段
九十歲老頑童 張廣德
2020 年 12 月於北京

Preface

Hearing that the book "Ba Duan Jin for Children", written by the Ph.D. and master students of Professor Hu Xiaofei, is about to be published, I was full of joy. I was delighted because another treasure would be added to the Chinese Wushu and Daoyin Health Preservation System soon. For this, I warmly congratulate the book on its grand publication.

Professor Hu Xiaofei is a well-known Daoyin Health Preservation scholar in China. He is also a famous Health Qigong theorist and practitioner abroad. He has written a lot of books, such as "Qianlong Health Preservation Technique", "Ba Duan Jin for Strengthening the Body", "Wheelchair Fitness Technique", "Pre-Warm-up of Sports Health Preservation Exercise" and "Health Building Foundation Skills", which was co-authored with me, etc. It was proven that these books have important pioneering significance for the dissemination and development of Chinese traditional culture, Wushu culture, and Daoyin culture.

When I was excited about writing the preface of this book, I suddenly remembered what Mr Gao Niansheng said in the preface of "Germany Children's Fiction", "Throughout the ages, countries around the world have published numerous outstanding works for children, which are as vast as star, and dazzling. The books have been exchanged and disseminated among various ethnic groups, nurturing generations of children. Famous fairy tales such as "The Little Match Girl", "The Emperor's New Clothes", and "The Fisherman and the Golden Fish" have already crossed the boundaries of countries, broke through the barriers of time, and become the spiritual wealth shared by the children of all countries."

Now, Professor Hu Xiaofei has used the experience of writing children's books and used the form of ballads to create "Ba Duan Jin for Children", which integrates knowledge, ideology, practicality, entertainment, fun, and the "four educations" which are morality, intelligence, physical and aesthetic. It has a beautiful image, and is simple and lively, easy to learn with vivid language. It is suitable for children from different countries to learn, so as to achieve the purpose of fitness.

In short, in my opinion, the idea between the lines of the book "Ba Duan Jin for Children" is novel, full of brilliance and innovation. It is a rare work of Wushu named Daoyin fitness.

Professor Hu Xiaofei invited me to write a preface,so I took the liberty of writing it freely. Sincerely recommend reading to children, parents and children's career workers from different countries. Hope you like it!

Professor of Beijing Sport University

The first Chinese reached level 9 in both Wushu and Health Qigong rank system

90-year-old old urchin, Zhang Guangde

Written in Beijing, December 2020

第一章
少兒八段錦概述

Chapter One

Overview of Ba Duan Jin for Children

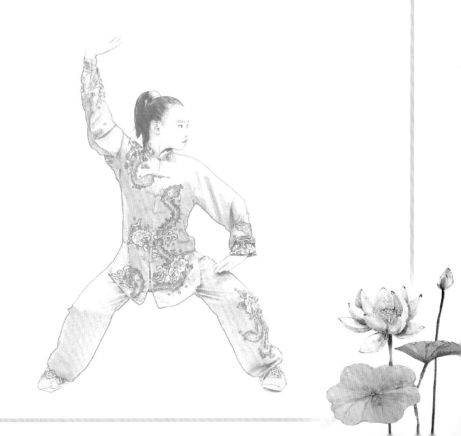

第一節 概念及簡介
Section One Concept and Brief Introduction

一、少兒八段錦的概念

少兒八段錦是一套武術健身術，它是在繼承古現代八段錦的基礎上， 以中國傳統文化為指導，以中醫理論為基礎，結合現代生物學、心理學和 有氧運動的理論，以古現代導引、武術練習為基本內容，通過套路練習和 歌訣詠唱相結合的形式，達到增進健康、塑形強體、增長知識、陶冶情操、 提振精神、激發愛國熱情為目的的健身術。具體如以下四個方面。

其一，少兒八段錦是由八段錦改編而來的，套路名稱為少兒八段錦； 動作名稱也是沿用八段錦名稱，如 "兩手托天理三焦" "調理脾胃須單舉" 等；動作數量也是八式，並且繼承了八段錦循脊取動、動靜相間、 抻筋拔骨、簡單易練的動作特點，以及對稱中正、連貫圓活、瀟灑大方、 神形兼備的練習風格，具有良好的繼承性和延續性，只是將動作順序和個 別字稍加變化使之更加符合少兒的生理負荷規律。

其二，少兒八段錦蘊含豐富的中國文化元素，指導思想在於協調陰陽， 提倡平衡、和諧；鍛煉以自我為主，註重整體調攝，目的在於強內壯外；動作名稱和歌訣內容蘊含著豐富的中華文化和中醫知識；在練習手段上， 以武術和傳統導引健身術為基本內容；在練習效果上，不僅強調保養身體， 增進健康，而且註重情操的陶冶，體現出陽光、自強、博愛和愛國的價值 觀；少兒通過練習可以充分地汲取中國傳統文化營養，學習中醫保健知識， 領略中國智慧。

其三，少兒八段錦體現了少兒的生理及心理特點，不僅在動作設計上 體現出明快活潑、快慢相間、錯落有致的特點，而且還配以朗朗上口、節 奏感強的練習歌訣；音樂的編排也與少兒陽光、活潑、天真的性格相匹配。 使少兒練習者不僅能很好地掌握技術、歡樂練習，而且可以在享受中獲得 良好的、全方位的鍛煉效果。

其四，少兒八段錦促進少兒身心的全面提升，通過少兒八段錦的鍛煉，不僅能達到增強體質、塑造形體、陶冶情操、開闊心胸的目的，還能為孩 子們獲得中醫知識、增強民族自豪感和提升愛國熱情服務。

1.Concept of Ba Duan Jin for Children

Ba Duan Jin for Children is a set of Wushu fitness techniques which inherits the ancient and modern Ba Duan Jin. It is guided by traditional Chinese culture and based on Chinese medicine theories, combined with modern biology, psychology and aerobic exercise theories, and based on ancient and modern guidance and Wushu exercises. Through the combination of routine exercises and chanting, this fitness technique achieves the purpose of improving health, shaping and strengthening the body, increasing knowledge, cultivating sentiment, boosting the spirit, and stimulating patriotic enthusiasm. Specifically as the following four aspects.

Firstly, Ba Duan Jin for Children is adapted from Ba Duan Jin, and the name of the routine is Ba Duan Jin for Children. The movement names also follow those of the Ba Duan Jin, such as " Holding the Hands High with Palms Up to Regulate the Internal Organs ", " Holding One Arm Aloft to Improve the Spleen and Stomach", etc; There are also eight movements in Ba Duan Jin for Children, and it inherits the characteristics of Ba Duan Jin that moves along the spine, stretches the muscles and bones, having both dynamic and static combination, and having simple and easy movements for practice, as well as the practice style of symmetrical centering, coherent and smooth, chic and generous, and having unity of form and spirit. It has good inheritance and continuity, just slightly changing the sequence of movements and individual words can make it more in line with the law of children's physiological load.

Secondly, Ba Duan Jin for Children contains rich Chinese cultural elements. The guiding ideology is to coordinate Yin and Yang, and promote balance and harmony; the exercise is mainly self-centered and focusing on the overall adjustment, and the purpose is to strengthen the inside and outside of the body; the name of the movements and the content of the song contain rich Chinese culture and Chinese medicine knowledge; in terms of practice methods, the basic content are Wushu and traditional Daoyin fitness techniques; in terms of the effect of the practice, it not only emphasizes the maintenance of the body and the improvement of health, but also the cultivation of sentiment, which reflects the values of sunshine, self-improvement, fraternity and patriotism; children can fully absorb the nutrition of Chinese traditional culture through practice, learn the knowledge of Chinese medicine and health care, and appreciate Chinese wisdom.

Thirdly, Ba Duan Jin for Children embodies the physical and psychological characteristics of children. It not only reflects the characteristics of bright and lively, fast and slow, and patchy in the movement design, but is also accompanied by catchy and rhythmic practice songs. The music arrangement also matches children's sunny, lively, and innocent character so that young practitioners can master the technique well and practice joyfully, and also get a good and all-round exercise effect in the enjoyment.

Fourthly, Ba Duan Jin for Children promotes the overall improvement of children's body and mind. Through the exercise of Ba Duan Jin for Children, it not only can achieve the purpose of strengthening the body, shaping the body, cultivating sentiment, and broadening the mind, but it also can provide children with knowledge of Chinese medicine, enhance national pride and enhance patriotic and enthusiastic service.

二、少兒八段錦的淵源

少兒八段錦在精研古現代八段錦的基礎上，根據少兒身心特點創編而 來。那麼，什麼是八段錦呢？它是怎麼來的？它在我國古代健身術中處於 何種地位呢？八段錦流行於宋代的經典導引術，它是精選前人導引保健 鍛煉之精華，以中醫理論為指導，以朗朗上口、緊密結合中醫原理的七 言四句歌訣為動作名稱，通過中正安舒的身體姿勢、抻筋拔骨的伸展脊柱、 圓連柔和的肢體活動，並結合細勻深長的腹式呼吸和綿綿若存的意識運用，以達調攝內臟、強健筋骨、增強體質、怡情養性目的的自我鍛煉。其 特點是簡便易學、結合醫理、美觀大方、效果顯著。對於八段錦，還有如下解釋。

其一，八段錦的 "錦" 字寓意豐富。① "錦" 字由 "金" 和 "帛" 構成， "金" 表示 "貴重" 物品， "帛" 在古代有 "珍稀" 的含義，古人在此借 用 "錦" 來表示八段錦的既 "珍" 且 "貴"。② "錦" 字又可以理解為 "織錦"， 其特點是連綿不斷，循環無端，結構合理，沒有瑕疵。在此表示，八段 錦練習由單個導引術式合理構建而成，是一套完整合理的鍛煉方法，並 且如絲綢那樣圓連柔順。這就和當今風靡全球的有氧運動特征非常契合， 也為八段錦受到全球各界的追捧埋下伏筆。③ "錦" 還有 "集錦" 的意思， 在這裏借以表示八段錦是將我國宋代以前存在的優秀保健練習進行提煉、 巧妙合理建構的練習方法。④ "錦" 還有色彩鮮艷的含義，可用來表示 "美 麗" 和 "美好未來" 等寓意，如 "繁花似錦" "前程似錦" 等，在此表 示該功法優美大方和鍛煉效果的顯著性和持久性，使練習者在學練之 初，就喜歡它、熱愛它、享受它，並對將要獲得的健身效果充滿信心。

其二，八段錦的 "八" 字，不是單指段、節或八個動作，還表示練 習招式之間有多種要素，並且相互製約、相互聯系、循環運轉。正如八段 錦歌訣中提到的 "子前午後作，造化合乾坤；循環次第轉，八卦是良因" （《遵生八箋》 "八段錦導引法"）。

八段錦蘊含中華傳統文化，以中醫理論為基礎，近千年來流傳甚廣。 作為國家推薦的全民健身項目，它不僅深受廣大民眾的喜愛，也受到許多 專家、學者和名人的青睞，如文學家楊絳、民國元老於右任、革命家謝覺哉和徐特立等都長年堅持練習八段錦，進而獲得身心健康、得享高齡，傳 為佳話。歷史上八段錦有眾多出版者，據不完全統計，到目前為止，已正 式出版的八段錦就有 80 多個版本。以它為主的中國治療體操，於 18 世紀 就已傳入歐洲，並在現代衛生和治療方法上占有重要地位，為世界體育史 留下了精彩的一筆。

2.Origin of Ba Duan Jin for Childern

Ba Duan Jin for Children is based on the study of ancient and modern Ba Duan Jin and is created according to the physical and mental characteristics of children. So, what is Ba Duan Jin? How did it come from? What position does it occupy in ancient fitness techniques in our country? Ba Duan Jin is a classic guide technique popular in the Song Dynasty. It is the essence selected from predecessors' Daoyin health care exercise. It is guided by the theory of Chinese medicine, with catchy seven-character four-sentence verses as movement names that are closely integrated with the principles of Chinese medicine. Through calm, impartial and comfortable body posture, the stretching of spine by stretching the tendons and bones, the smooth and gentle limb activities, combined with deep abdominal breathing and the continuous use of consciousness, so as to achieve a self-exercise for the purpose of adjusting internal organs, strengthening the muscles and bones, enhancing physical fitness, and comforting one's emotions. Its characteristics are simple and easy to learn, combined with medical theories, with generous and beautiful movements, and with significant effect. For Ba Duan Jin, there are also the following explanations.

Firstly, the character "Jin" in "Ba Duan Jin" has a rich meaning. ① The word "Jin" （錦） is composed of "Jin" （金）and "Bo" （帛）,which means gold and silks respectively. Gold refers to "valuable" objects. Silks had the meaning of "rare" in ancient times. The ancients therefore used "Jin" to mean that Ba Duan Jin is both "precious" and "expensive". ② Moreover, The character "Jin" can be understood as "brocade", which is characterized by continuous circulation, reasonable structure and without flaws. This means that Ba Duan Jin exercise is reasonably constructed from a single Daoyin (guiding) technique, which is a complete and reasonable set of exercise methods, and is as smooth as silk. This matches with the characteristics of aerobic exercise that is popular all over the world today, and it also paves the way for Ba Duan Jin to be sought after by all walks of life around the world for foreshadowing. ③ The character "Jin" also means "Jijin" (combining something), it is used to indicate that Ba Duan Jin is an exercise method that refines, and ingeniously and reasonably constructs the excellent health care exercises that existed before the Song Dynasty in my country. ④ Furthermore, the character "Jin" has the meaning of bright and colourful, which can be used to represent "beautiful" and "bright future", etc., such as "flowers blooming like a piece of Jin (brocade)", "one's prosperity is as beautiful as Jin (brocade)", etc. Here it shows that Ba Duan Jin is beautiful and generous, and the effect of this exercise is remarkable and persistent, so that the practitioner will like it, love it, and enjoy it at the beginning of learning and practice, and be confident in the fitness effect that will be obtained.

Secondly, the character "Ba", which means "eight", in Ba Duan Jin is not just referring to a single finger segment, stanza or eight movements, but also means that there are multiple essential elements in the practice of the movements, and they are mutually restrained, interconnected, and circulated. As mentioned in the Ba Duan Jin song, "make it before and after midday, making the world together; the cycle turns, the gossip is the good cause" ("Zunsheng Bajian" "Ba Duan Jin Daoyin Method'').

Ba Duan Jin contains traditional Chinese culture and is based on the theories of Chinese medicine. It has been widely spread for nearly a thousand years. As a national fitness program recommended by the country, it is not only well loved by the general public, but also favoured by many experts, scholars and celebrities, such as literary author Yang Jiang, the Republican veteran of China Yu Youren, the revolutionaries Xie Juezai and Xu teli, etc. They all insist on practising Ba Duan Jin and they have gained physical and mental health and enjoy advanced age. There were many publishers of Ba Duan Jin in history. According to incomplete statistics, there are more than 80 editions of Ba Duan Jin that have been officially published so far. The Chinese therapeutic gymnastics based on it has been introduced to Europe in the 18th century, and it occupies an important position in modern hygiene and treatment methods, leaving a wonderful stroke in the history of world sports.

第二節 創編意義和原則
Meanings and Principles of Creation

一、創編少兒八段錦的意義
The meanings of creating Ba Duan Jin for Children

（一）弘揚中華優秀文化

中國傳統文化是中華民族五千年文明的結晶，是中華民族的獨特標識，是四大古文明中唯一沒有中斷的文明，是中華民族在長期生產生活實踐中產生和形成的，為中華民族的生息、發展和壯大提供了豐厚的精神養料。其中蘊含著"仁義""和合""和平""和諧"的中和思想，承載著"大道之行也，天下為公"的社會理想，"天下興亡，匹夫有責"的愛國理念，"以和為貴，和而不同"的處世哲學，"天人合一，道法自然"的生命境界。

（二）豐富教育，拓寬渠道

少兒八段錦可以豐富學校體育的教育功能，拓寬中小學體育活動的開展和應用渠道。因為少年兒童活潑好動，求知欲望極強，加之課業任務繁重，急需要一些既能活動身體，又能鍛煉腦力，既能增進健康，又可學習知識，既有趣味性，又有思想性，既可提高技能，又可開發智力的一舉多得、事半功倍的教育方法和手段，並且合理有效地應用到學校教育的各個方面，為豐富學校教育手段、推進學校教育改革、落實黨的教育方針做出有益貢獻。

少兒八段錦的練習內容、方法、形式、目的作用豐富而開放。具體來說，其既可作為中小學體育課教學內容，又可用於課間操、課外活動；既可用 於室外教學，又可作為室內教材；既可用於社區實踐內容，又可作為文藝 表演節目；既可增強體質，又可增進知識；既可強體塑形，又可怡情勵誌， 進而為培養祖國的棟梁之材服務。

1. Promote the excellent Chinese culture

Chinese traditional culture is the crystallization of five thousand years of civilization of the Chinese nation, a unique identifier of the Chinese nation, the only uninterrupted civilization among the four ancient civilizations, and was produced and formed by the Chinese nation in the long-term practice of producing life. It provided abundant spiritual nourishment for the survival, development and growth of the Chinese nation. It contains the neutral thoughts of "benevolence and justice", "harmony", and "peace ", and carries the social ideal of " When the self-cultivation and ability of people are manifested in the world, the world is common to all people. People will recommend those with high moral character, both ability and political integrity, to run the country ", the patriotic concept of " Every ordinary person has a responsibility for the prosperity or decline of a country. ", the philosophy of life of "Harmony is the most precious, be peaceful with different voices" , and the life state of "Unit men and nature, do not destroy the harmony and all things in nature" .

2. Enrich education and broaden channels

Ba Duan Jin can enrich the educational function of school physical education and broaden the development and application channels of sports activities in primary and secondary schools. Since children are lively and active, having a strong desire for knowledge, and coupled with lots of academic tasks, they are in urgent need for educational methods and means that help them achieve a lot at one stroke and get twice the result with half of effort, not only move the body, but also exercise the brain; not only improve health, but also acquire knowledge, not only improve skills, but also develop intelligence; and are both interesting and ideological. They also urgently need to apply them to all aspects of school education in a reasonable and effective manner to make useful contributions to enriching school education methods, advancing school education reform, and implementing the party's education policy.

The practice content, method, form, purpose and function of Ba Duan Jin for Children are rich and open. Specifically, it can be used not only as the teaching content of physical education in primary and secondary schools, but also for inter-class exercises and extracurricular activities; it can be used for outdoor teaching and indoor teaching materials, community practice content and a cultural performance program; not only enhancing physical fitness, but also advancing knowledge; not only strengthening the body, but also be happy and inspiring, and thereby serve for the cultivation of the pillars of the motherland.

二、創編少兒八段錦的原則

Principles of Compiling Ba Duan Jin for Children

（一）科學針對性原則

創編少兒八段錦，要以科學的態度，遵循科學規律，以科學理論為指導，針對少年兒童身心發育的特點和成長規律來進行。

1. Scientific pertinence principle

The compilation of Ba Duan Jin for Children based on the principle of scientific pertinence. It is necessary to adopt a scientific attitude, follow scientific laws, and be guided by scientific theories, aiming at the characteristics and growth patterns of the physical and mental development of young children.

（二）多元高效性原則

創編少兒八段錦，既要重視功法中包含元素的多樣性、全面性，又要強調通過有限的鍛煉時間達到提高少年兒童身心健康的目的。

2. Elements validity principle

When compilating Ba Duan Jin for Children, it is necessary to pay attention to the diversity and comprehensiveness of the elements contained in the exercises, and also to emphasize the purpose of improving the physical and mental health of children and teenagers through limited exercise time.

（三）簡單實用性原則

創編少兒八段錦，要力求簡單、易學、好練，而且還注重使其符合黨的教育方針和學校教育各個目標的需要，要滿足中小學的現有條件，適合在中小學開展。

3. The principle of simplicity and practicality

When compilating Ba Duan Jin for Children, it is necessary to be simple, easy to learn, and easy to practice, and also to meet the needs of the party's education policy and school education goals, meet the existing conditions of primary and secondary schools, and to be suitable for development in primary and secondary schools.

（四）繼承發展性原則

創編少兒八段錦，既要繼承中國傳統文化的精髓，借鑒傳統八段錦的精華，又要根據少兒身心特點和現代教育理念，在內容、方法、形式等方面進行創新。

4. Inheritance and developmental principle

When compilating Ba Duan Jin for Children, it is necessary to inherit the essence of traditional Chinese culture, learn from the essence of traditional Ba Duan Jin, and innovate in content, methods, and forms according to the physical and mental characteristics of children and modern educational concepts.

（五）靈活趣味性原則

在創編少兒八段錦時，要體現出動作靈活多變和套路、形式、時間的可調性，練習手段、方法的活潑多樣性和練習內容、文化知識的有趣性，防治僵化、呆板、枯燥地套用前人的理論方法。

5. Flexible and fun principle

When compilating Ba Duan Jin for Children, it is necessary to reflect the flexibility of movements and the adjustability of routines, forms, and time, the lively diversity of practice methods, and the fun of practice content and cultural knowledge, and prevent rigid, dull, and boring application of predecessors' theoretical methods.

第三節 作用原理及風格特點
The Working Principle of Ba Duan Jin for Children

一、少兒八段錦的作用原理
The Working Principle of Ba Duan Jin for Children

（一）強體健身，提高素質

少兒八段錦繼承了原有八段錦注重全身活動、抻筋拔骨、梳理脊柱，並根據中醫原理調攝五臟功能、調和精神氣血的基本理念和方法、特點，可以有效地暢通練習者全身氣血，使其臟腑功能得到改善，身體健康水準提高。同時，中醫認為，"有諸內者，必行諸外"，包括"脾主肌肉""腎主骨"等，因此，通過練習還可達到以內養外、強壯身體的目的，這有助於幫助處在生長期的少兒茁壯成長。此外，少兒八段錦十分強調"快慢相間""剛柔相濟"和"勢正招圓"的練習特點，提出了－－些需要快速多變、協調配合的動作要求，設計了大幅度俯身折疊、馬步、橫襠步、獨立步等武術招式，從而可有效提高少年兒童的力量、柔韌、靈敏、協調和速度素質，練就靈活矯健的身手，從而不僅可有力地提升其應對突發的人為傷害和自然災害事件的能力，還可以幫助其提高運動能力，為開展各項體育運動訓練打下堅實的基礎。

1.Strengthen the body and improve quality

Ba Duan Jin for Children inherits the original Ba Duan Jin's basic concepts, methods and characteristics of focusing on body activities, stretching the tendons and bones, combing the spine, and adjusting the functions of the five internal organs and reconciling the spirit and blood according to the principles of Chinese medicine. It can effectively unblock children's whole-body Qi and blood, so that the function of internal organs and the health of the body can be improved. At the same time, Chinese medicine believes that "You Zhu Nei Zhe, Bi Xing Zhu Wai", including "the spleen governs the muscles" and "the kidney governs the bones". Therefore, through exercises, children can also achieve the purpose of internally nourishing the external self and strengthening the body, which helps children who are in the growing period. In addition, Ba Duan Jin for Children emphasizes the practice characteristics of "fast and slow speed", "hardness and softness", and "regular postures with smooth movements", and put forward some movement requirements that require rapid change, coordination and cooperation, and designed a large bending and folding, Wushu movements such as horse stance, horizontal stance, single-foot stance, etc., so that it can effectively improve the strength, flexibility,

agility, coordination and speed of children, and develop flexible and vigorous skills, which can not only effectively improve their response to sudden artificial actions, but also develop the ability of responding to injury and natural disaster events and help them improve their athletic ability and lay a solid foundation for the development of various sports training.

（二）矯形塑體、激發朝氣

少兒八段錦繼承了古八段錦式正招圓、抻筋拔骨的技術風格，並且整個練習動作.上注重大幅度、用內勁；結構上強調上頂下沉、前推後頂、左撐右拉；意識上講究放長放遠等要求，長期練習，可使少年兒童形成挺拔的身姿、端正的身形、大方的舉止和優美的姿態。同時，練習中設計的針對刺激頸部大椎穴和定喘穴的大幅度旋轉，針對脊柱和"三焦"的大幅度撐拉，都有助於達到調整身姿、塑形健體、提升陽氣之目的，避免"豆芽菜"式的體型蔓延。再者，如抻筋拔骨、怒目瞪視、左顧右盼等動作還具有疏肝理氣、調節眼肌的作用，對改善少兒的視力、預防近視眼有重要意義。

2. Orthopedics and body shaping, inspiring vitality

Ba Duan Jin for Children inherits the ancient Ba Duan Jin style of regulating the postures and smoothing the movements, stretching the tendons and pulling the bones, and in the whole exercise, pay attention to large amplitude and use internal strength; in the structure, it is emphasized that the top is up and the bottom is sinking, pushing forward and pulling back, and pulling left and right; in the structure, it is emphasized the long-term and far-reaching requirements, long-term practice, which can make children learn to form upright postures, upright physiques, generous manners and graceful postures. At the same time, the exercise is designed to stimulate the large rotation of the acupoint Dazhui and Dingchuan in the neck, and the large support for the spine and the "Sanjiao", which all help to adjust the posture, shape and improve Yang Qi. The purpose is to avoid the spread of "bean sprouts" body shape style. Furthermore, movements such as stretching the muscles and bones, glaring in anger, looking left and right, etc., also have the functions of soothing the Qi in liver, and regulating the eye muscles, which are of great significance for improving children's vision and preventing myopia.

（三）提振精神，陶冶情操

少兒八段錦在全身運動柔緩圓連的基礎上，融入了動作的快慢相間、剛猛有力和剛柔相濟的元素，同時將剛猛發力與吼聲陣陣結合起來，從而可有效地提振孩子們的陽剛之氣。植根於傳統養生文化的少兒八段錦，始終強調身心合一，即"形神共養"的原則，再加上歌訣中融入大量的積極向上、怡情修德的詞句以及激發孩子們保家衛國熱情的愛國故事，這些都對幫助孩子們陶冶情操、勵志修心、提振陽剛之氣具有重要作用。

3. Boost the spirit and cultivate the sentiment

On the basis of the gentle and circular movement of the whole body, Ba Duan Jin incorporates the elements of the speed of fast and slow, and the combination of hard strength and softness. At the same time, it combines fierce force with roar bursts, which can effectively boost the masculinity of children. Ba Duan Jin for Children, which is rooted in the traditional health-preserving culture, always emphasizes the unity of body and mind, that is, the principle of "form and spirit co-cultivation". In addition, the song incorporates a large number of positive, emotional and moral words and passionate patriotic stories which inspires children to protect their country, these all play an important role in helping children cultivate their sentiments, inspire their hearts and mind, and boost their masculinity.

（四）拓知益智，體悟文化

少兒八段錦注重繼承傳統健身文化思想和理念，具有較強的文化內涵特點，不僅每式動作名稱文化內涵豐富，且每式歌訣均按結構、功能、特點、功效等將中醫知識和愛國精神以朗朗上口的七言歌訣句的形式加以展現。在完成動作技能的學習過程中，通過歌訣的朗誦，對加深少兒對中醫文化的瞭解可以起到潛移默化的薰陶作用，從而起到弘揚中醫文化的效果。加之，練習形式、方法和要求充滿著中國傳統文化的陰陽平衡、中庸和諧的理念，使練習者通過長期練習自覺體驗來建立中和之道的哲學理念，為繼承和發展中華文化打下基礎。練習中放鬆大腦皮質、吟練結合的方式，還可有效促進少兒的腦細胞發育、提高記憶力、發展智力。

4. Expand knowledge, understand culture

Ba Duan Jin for Children pays attention to inheriting traditional fitness cultural thoughts and concepts, and has strong cultural connotation characteristics. Not only does the name of each movement have rich cultural connotations, but also each seven-character sentence of song integrates Chinese medicine knowledge and patriotism according to structure, function, characteristics, and efficacy. In the process of completing the learning of movement skills, the recitation of chants can play a subtle role in deepening children's understanding of Chinese medicine culture, thereby promoting the effect of Chinese medicine culture. In addition, the practice forms, methods and requirements are full of traditional Chinese culture's concepts of Yin and Yang balance and harmony, enabling children to establish the philosophical concept of the way of neutralization through long-term practice and conscious experience, laying a foundation for the inheritance and development of Chinese culture. The method of relaxing the cerebral cortex and combining chanting and training in exercises can also effectively promote the development of children's brain cells, improve their memories, and develop intelligence.

二、少兒八段錦的風格特點

(一) 勢正招圓，舒展大方

"勢正招圓" 是指身體中正安舒，動作規範準確，形體不僵不拘，形體、 姿勢、動作軌跡及勁力趨勢圓潤飽滿、連綿不斷、循環無端；"舒展大方" 表示練習要註重大幅度伸展，其肢體要放長放遠，體現出瀟灑飄逸、優美 大氣的風格特點，不可生硬僵化、直來直往、縮手縮腳、畏首畏尾。

形正有助於放松身心，暢通氣血，收斂思緒。古人認為："形不正則氣 不順; 氣不順則意不寧; 意不寧則神散亂。"圓活則符合自然界生物的周期 性變化規律，也符合人體臟腑氣機的升降運動，以及人體十二經脈中氣血 運行的循行路線，從而起到促進人體各臟腑及經絡的協調與平衡的作用。舒展大方則有利於抻筋拔骨、放松肢體、刺激經絡穴位，進而達到暢通經絡、運行氣血的目的。

(二) 松緊結合，動靜相兼

"松" 是指身體和心理的放松，"緊" 是指在肢體放松過程中的逐漸加 力和突然發力；"動" 是指練習過程中的身體運動和心理活動，"靜" 則是 指相對於 "動" 的穩定狀態。因此，該特點表示要在綿緩輕松的練習過程 中適當用力，並且要以動為主，寓靜於動，註重外動和内靜、形靜和神動 的有機結合，使之相得益彰，不可偏廢。

松和動，有助於氣血暢通，改善身體機能，促進生長發育; 而緊和靜，則有助於刺激經絡穴位、啟動内氣、疏通經絡、保健臟腑，還可有效地牽 拉活動的脊柱、關節和四肢百骸，有助於思想的集中，達到蓄勁和放松大 腦的目的。"松緊結合，動靜相兼"的特點無疑對協調練習者陰陽、改善 身心健康有利，同時也可幫助其體驗陰陽平衡的内涵，樹立和諧的哲學觀 和文化理念。

(三) 剛柔相濟，快慢相間

"剛柔相濟" 是指動作招式的迅捷有力，神態的虎虎生威和動作的連貫圓活、柔和緩慢、瀟灑飄逸；"快慢相間" 則是指練習時動作節奏有快有 慢，先快後慢、先慢後快的有機結合，使練習表現得活潑生動，歡快有趣， 並蘊含著陰陽兼濟、陰平陽秘的文化色彩，符合少兒身心特征和中國傳統 文化特色。

"剛猛快捷"，符合少年兒童活潑好動的天性，可以有效增強孩子們的 爆發力、靈活性等素質，幫助他們提升陽氣，提振精神。"柔和緩慢"則 可以有效地調整呼吸、集中精神，從而為 "剛猛快捷" 蓄力。同時，在整個套路中，這一特點可有效幫助練習者放松身心、調節呼吸、寧心斂神， 並可有效地避免運動損傷和意外的發生; 對練習者體會陰陽和合，建立和 諧思維方式具有潛移默化的作用。

（四）簡單易練，活潑典雅

"簡單易練"指的是，動作方法、理論知識、創編原理和呈現方式比較簡單，對身體和場地、季節、場合等也沒有過高的要求，適合在體育課、課外活動和課間操開展，便於孩子們掌握和學校的推廣。"活潑典雅"指的是，既繼承了傳統八段錦和武術古樸沈穩的基因，又融入了輕鬆自如、協調歡快的元素及形式，滿足少兒群體靈動的、有朝氣的、積極向上的天性，使孩子們一接觸它，便會很容易喜歡它，掌握它。

老子提出"大道至簡至易"。"簡單易練"有助於孩子們較好地掌握功法技術，使他們有成功感，有信心，也適合中小學教師在各種活動中有效地利用，便於少兒八段錦的推廣。而"活潑典雅"既有助於愉悅心情，改善少年兒童的心理，激發他們奮發向上的朝氣，促進其樹立正確的人生觀，又可幫助孩子們修養心性，體驗中華傳統文化的含蓄美、端莊美，從而培養孩子們沈穩、內斂、處變不驚的良好氣質，使中華傳統文化得以傳承。

（五）動息相隨，形神相依

"動息相隨"指的是練習和呼吸調節緊密結合，而且動作柔緩圓勻要為呼吸調節服務。反過來，呼吸的調節也要為動作發力服務。"形神相依"指的則是練習過程中肢體和精神、動作和意識要有機結合。動作的正確合理要為意念的聚精會神服務，反過來，意境的深入也可幫助動作、姿態更加正確合理。"動息相隨"不僅能有效地加深呼吸，減少呼吸頻率，增強少年兒童心肺功能，改善肝脾胃血液循環，促進新陳代謝水平的提高，以氣催力的鍛煉還可以使其穿掌、拍股、沖拳迅捷有力，吼聲震天，氣勢恢宏，達到強體壯力，激發孩子們朝氣之目的。而"形神相依"則不僅讓人聚精會神，動作準確到位，還能為提高練習效率服務，能有效地淨化大腦，促進經絡暢通、氣血循環，對提高學習效率、陶冶情操、提振精神也具有重要作用。

（六）練詠結合，智體同修

"練詠結合"是指功法練習要和歌訣詠唱互相配合，做到邊練邊頌、邊頌邊練，達到文體一家、武藝兼修的目的。"智體同修"是指練習少兒八段錦不僅要為增強體質、塑形修身服務，而且要為其拓展知識、開發智力服務。

少兒八段錦與其他八段錦和健身術的最大區別就在於，它為每一式都編寫了朗朗上口的七言歌訣，孩子們可以邊練邊詠唱。而在歌詠中又包含豐富的中醫理論知識，愛國勵誌故事和中國傳統文化思想，使孩子們通過學習增長知識、改善思維、激發熱情、陶冶情操，進而為提升中國智慧服務。這樣的練習方式還可有效調動孩子們的興趣，激發起學練熱情，促進其體質、智力和情誌的全面提升。而"智體同修"的特點則有助於幫助孩子們在有限的時間裏獲得豐富知識，思想進步和身體健康雙豐收。

2. The style and characteristics of Ba Duan Jin for Children

1.Impartial postures, mellow movements

"Impartial postures, mellow movements" means the center of gravity is impartial and the body is comfortable, the movements are standardized and accurate, the shape of body is not stiff and cautious, the shape of body, posture, movement trajectory and change in strength are mellow and full, continuous, and endless; "stretching generously" means paying attention to large extend of stretching when practising, the limbs should be stretched longer and farther, reflecting the characteristics of chic, elegant, and graceful, not stiff and rigid, not straight-forward, not shrinking and fearful.

An impartial posture helps to relax the body and mind, ventilate the blood, and converge thoughts. The ancients believed, "if the posture is not impartial, the Qi (breath) will be poor; if the breath is poor, the mind will be restless; if the mind is restless, the spirit will be distracted." Being mellow conforms to the cyclical changes of natural organisms, as well as the lifting and lowering movement of the visceral organisms, as well as the circulation route of the vital Qi and blood in the body' s twelve meridians, thereby promoting the coordination and balance of the body' s viscera and meridian. Stretching generously is beneficial to stretch the tendons and bones, relax the limbs, stimulate the meridian points, and then achieve the purpose of unblocking the meridians and running the blood.

2. Combination of relaxation and tightness, with both motion and calmness

"Relaxation" refers to physical and mental relaxation, "tightness" refers to the gradual increase and sudden exertion of force in the process of body relaxation; "motion" refers to the physical and mental activities during the practices, and "calmness" refers to a stable state relative to "motion". Therefore, this feature means that appropriate force should be used in the slow and relaxed practice process, and should be focused on motion, combine calmness with motion, and pay attention to the organic combination of external motion and internal calmness, body calmness and mind motion. Make them complement each other, do not neglect or be partial to one of them.

Relaxation and motion help to unblock the Qi and blood, improve physical functions, and promote growth and development; while tightness and calmness help to stimulate the acupuncture points, activate internal Qi, unblock the meridians, protect the viscera, and effectively stretch the active spine, joints, and limbs, thus help to concentrate the mind and achieve the purpose of accumulating energy and relaxing the brain. The characteristic of "relaxation and tightness, with both motion and calmness" are undoubtedly beneficial to coordinate practitioners' Yin and Yang, and improve their physical and mental health. At the same time, it also helps them experience the connotation of Yin and Yang balance and establish a harmonious philosophical and cultural concept.

3. Rigidity and softness mutually benefit each other, alternate between fast and slow speed

"Rigidity and softness mutually benefit each other" refers to swift and powerful movements, awing demeanor, and coherent, soft, slow, and elegant movements; "Alternate between fast and slow speed" means having both fast and slow movements during the practices, and the organic combination of "fast first, then slow" and "slow first, then fast" , making the exercises lively and lively, cheerful and

interesting, and contain the cultural colors of Yin and Yang, with dynamic balances between Yin and Yang, in line with children's the physical and mental characteristics and the characteristics of Chinese traditional culture.

"Rigidity and fast" is in line with the lively and active nature of children. It can effectively enhance children's explosiveness, flexibility and other qualities, help them improve their Yang Qi and boost their spirit. "Softness and slow" can effectively adjust breathing and focus, thereby accumulating energy for "rigidity and fast". At the same time, in the whole routine, this characteristic can effectively help the practitioner relax the body and mind, regulate the breathing, calm and confine the mind, and effectively avoid sports injuries or accidents. It has a subtle effect on the practitioners to experience the harmony of Yin and Yang, and to establish a harmonious way of thinking.

4. Simple and easy to practice, lively and elegant

"Simple and easy to practice" means that the movements, methods, theoretical knowledge, creation principles and presentation ways are relatively simple, and there are no excessive requirements on the body, venue, seasons, or occasions. It is suitable to be launched during physical education lessons, extracurricular activities and inter-class exercises, so as to facilitate the children to master and promote in schools. "Lively and elegant" means that it not only inherits the simple and steady characteristics of the traditional Ba Duan Jin and Wushu, but also incorporates relaxed, coordinated, harmonious and cheerful elements and forms. It satisfies the smart, energetic, and positive nature of the children's group, so that it is easy for children to like it and master it as soon as they contact it.

Laozi (Lao Tzu) proposed that "Principles (basic principles, methods and laws) are extremely simple". "Simple and easy to practice" helps children to better master the methods and techniques, so that they have a sense of success and confidence, and makes it also suitable for secondary and primary school teachers to use it effectively in various activities and facilitate the promotion of Ba Duan Jin for Children. And "lively and elegant" not only helps to feel happy, improve the psychology of children, stimulate their vigor and uplift, and promote them to establish a correct outlook on life, but also help children cultivate their temperament and experience the implicit beauty and dignity of traditional Chinese culture, thereby cultivating children's good temperament that is calm, introverted, with presences of mind in the face of disasters, so that traditional Chinese culture can be passed on.

5. Movements and breath follow each other, postures and mind depend on each other

"Movements and breath follow each other" refers to the close integration of exercise and breathing regulation, and the movements should be gentle and round so as to help the breathing regulation. Conversely, the adjustment of breathing should also help the movements. "Postures and mind depend on each other" refers to the organic integration of body and spirit, movements and consciousness in the process of practice. The correctness and rationality of the movements should help the concentration of the mind. Conversely, the deepening of consciousness can also help the movements and postures to be more correct and reasonable. "Movements and breathing follow each other" can not only deepen breathing effectively, reduce the frequency of breathing, enhance children's cardiopulmonary function, improve blood circulation of liver, spleen and stomach, and promote the increase of metabolism level,

exercise with Qi driving with force can also make the movements of piercing palms, slapping butt and punching more swift and powerful, roaring more loudly, and the momentum be more magnificent, thus achieving the purpose of strengthening physical strength and inspiring children's vitality. "Posture and mind depend on each other" not only makes people concentrate, the movements accurate, but also help improving the efficiency of practice, purifying the brain effectively, promoting the smooth flow of the meridians and the circulation of blood. It also plays an important role in improving learning efficiency, cultivating sentiment, and boosting the spirit.

6. Combination of practice and chanting, intellectual and physical cultivation

"Combination of practice and chanting" means that the practice of skill and chanting of rhymes should cooperate with each other, so as to practice while singing and practice while singing, so as to achieve the purpose of integrating style and Wushu " "Intellectual and physical cultivation" refers to the practice of Ba Duan Jin for Children, which should not only serve to enhance their physique, shape and cultivate their physique, but also expand their knowledge and develop their intelligence.

The biggest difference between Ba Duan Jin for Children and other Ba Duan Jin and fitness techniques is that it has written catchy seven character Rhymes for each type, and children can sing while practicing. The singing also contains rich theoretical knowledge of traditional Chinese medicine, patriotic inspirational stories and traditional Chinese cultural thoughts, so that children can learn to increase knowledge, improve thinking, stimulate enthusiasm and cultivate sentiment, so as to serve the improvement of Chinese wisdom. Such practice can also effectively mobilize children's interest, stimulate their enthusiasm for learning and practice, and promote the overall improvement of their physique, intelligence and emotion. The characteristics of "intellectual and physical fellow practitioners" help children gain rich knowledge, ideological progress and good health in a limited time.

第二章
少兒八段錦歌訣和釋義

Chapter Two
Songs and Interpretation of
Ba Duan Jin for Children

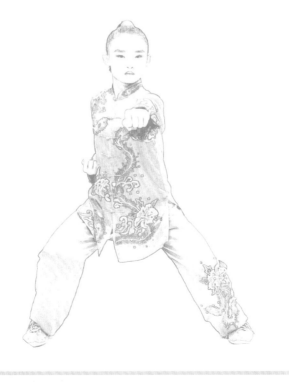

第一節　少兒八段錦全版歌訣
Section One　Full Version Songs of Ba Duan Jin for Children

一、編寫歌訣的基本思路

（1）歌訣為七言四句格式，目的是傳播中醫知識和武術知識技能，提 示練習方法要領，增加學練興趣和提高練習效果。

（2）格調清新活潑，明快優美，朗朗上口，符合少兒的身心特點。

（3）不追求生硬押韻，以朗朗上口、好聽、好記、好理解、正能量為 編寫目的。

（4）每式四句歌訣各自代表專門的含義。具體為：第一句，告訴臟腑 位置和該臟腑在生命健康中扮演的角色; 第二句，介紹該臟腑的主要功能 作用; 第三句，提示該式練習的方法要領; 第四句，說明該式的練習目的 和作用。

1.The basic thoughts of composing the song

(1) The song is in seven-character four-sentence format. The purpose is to spread the knowledge of Chinese medicine and Wushu, prompt the essentials of practice methods, increase interest in learning and practice, and improve practice effects.

(2) The style is fresh and lively, bright and beautiful, catchy, and in line with the physical and mental characteristics of children.

(3) Do not pursue blunt rhymes, write for the purpose of being catchy, good-sounding, easy-to-remember, easy-to-understand, and with positive energy.

(4) Each four-sentence verse in each movement represents its own special meaning. Specifically: the first sentence tells the position of the viscera and the role that the viscera play in life and health; the second sentence introduces the main functions of the viscera; the third sentence prompts the methods and essentials of the practice; the fourth sentence explains the purpose and function of the practice.

二、少兒八段錦歌訣內容

2. Content of the Ba Duan Jin for Children Song

【兩手托天理三焦】
三焦通行上中下，
通調水道行元真，
擎天柱地拔腰體，
塑形強體添精神！

【Holding the Hands High with Palms Up to Regulate the Internal Organs】
San Jiao Tong Xing Shang Zhong Xia,
Tong Tiao Shui Dao Xing Yuan Zhen,
Qing Tian Zhu Di Ba Yao Ti,
Su Xing Qiang Ti Tian Jing Shen!

【五勞七傷往後瞧】
大椎定喘藏頸肩，
益氣通陽沖九天，
左顧右盼放眼望，
神形疾患莫可犯！

【Looking Backwards to Prevent Sickness and Strain】
Da Zhui Ding Chuan Cang Jing Jian,
Yi Qi Tong Yang Chong Jiu Tian,
Zuo Gu You Pan Fang Yan Wang,
Shen Xing Ji Huan Mo Ke Fan!

【調理脾胃須單舉】
脾胃後天定中原，
運化水谷血氣全，
頂天立地撐與按，
氣血充盈身體健！

【Holding One Arm Aloft to Regulate the Functions of the Spleen and Stomach】
Pi Wei Hou Tian Ding Zhong Yuan,
Yun Hua Shui Gu Xue Qi Quan,
Ding Tian Li Di Cheng Yu An,
Qi Xue Chong Ying Shen Ti Jian!

【左右開弓似射雕】
肺為相傳曰華蓋，
主司呼吸朝百脈，
彎弓射箭勤學練，
豪氣雄姿育英才！

【Posing as an Archer Shooting Both Left- and Right-Handed】
Fei Wei Xiang Fu Yue Hua Gai,
Zhu Si Hu Xi Chao Bai Mai,
Wan Gong She Jian Qin Xue Lian,
Hao Qi Xiong Zi Yu Ying Cai!

【搖頭擺尾去心火】
心為君主地位尊，
統領五臟益血神，
搖頭擺尾融心腎，
水火相濟寧身心！

【Swinging the Head and Lowering the
Body to Relieve Stress】
Xin Wei Jun Zhu Di Wei Zun,
Tong Ling Wu Zang Yi Xue Shen,
Yao Tou Bai Wei Rong Xin Shen,
Shui Huo Xiang Ji Ning Shen Xin!

【攢拳怒目增氣力】
肝為將軍腎同源，
主筋通目智勇全，
怒目沖拳吼聲震，
武穆精神永流傳！

【Thrusting the Fists and Making the
Eyes Glare to Enhance Strength】
Gan Wei Jiang Jun Shen Tong Yuan,
Zhu Jin Tong Mu Zhi Yong Quan,
Nu Mu Chong Quan Hou Sheng Zhen,
Wu Mu Jing Shen Yong Liu Chuan!

【雙手攀足固腎腰】
腎為先天戍邊軍，
主骨生髓藏精魂，
俯身攀足頻蹲起，
強骨增力智常新！

Moving the Hands down the Back
and Legs, and【Touching the Feet to
Strengthen the Kidneys】
Shen Wei Xian Tian Shu Bian Jun,
Zhu Gu Sheng Sui Cang Jing Hun,
Fu Shen Pan Zu Pin Dun Qi,
Qiang Gu Zeng Li Zhi Chang Xin!

【背後七顛百病消】
經絡處處通身心，
運送氣血濡形神，
提踵顛足調百脈，
根深葉茂煥青春！

【Raising and Lowering the Heels to
Cure Diseases】
Jing Luo Chu Chu Tong Shen Xin,
Yun Song Qi Xue Ru Xing Shen,
Ti Zhong Dian Zu Tiao Bai Mai,
Gen Shen Ye Mao Huan Qing Chun!

第二節　少兒八段錦歌訣釋義
Section Two　Interpretation of Ba Duan Jin for Children

第一式【兩手托天理三焦】
Movement one【Holding the Hands High with Palms Up to Regulate the Internal Organs】

第一句　三焦通行上中下
The first sentence　San Jiao Tong Xing　Shang　Zhong Xia

用歌訣告訴小朋友們，三焦是分布或貫通軀幹從胸到腹上、中、下這 三個部位的。

三焦是中醫六腑之一，分布在上體的三個部位。上焦，是指胸膈以上部位，包括心、肺等臟腑在內；中焦指膈下、臍上部位，包括脾、胃等臟 腑；下焦指臍以下部位，包括腎、膀胱、小腸、大腸（從病理生理的角度，還包括部位較高的肝，故下焦往往肝、腎並提）。

Use the song to tell the children that San Jiao is distributed or penetrated through the three parts of the torso, from the chest to the upper, middle, and lower parts of the abdomen.

San Jiao is one of the six hollow organs in traditional Chinese medicine, distributed in three parts of the upper body. Upper Jiao refers to the part above the thoracic diaphragm, including the heart, lungs and other internal organs; middle Jiao refers to the part below the diaphragm and above the navel, including the spleen, stomach and other internal organs; lower Jiao refers to the part below the umbilicus, including the kidney, bladder, small intestine, and large intestine (From a pathophysiological point of view, it also includes the liver with a higher location, so the lower Jiao often refers to the liver and kidney together).

第二句 通調水道行元真

The second sentence Tong Diao Shui Dao Xing Yuan Zhen

用歌訣告訴小朋友們，通過暢通三焦經，調理三焦，可以起到改善人體的水液代謝、調節人體氣化功能、保養真元之氣的目的。

《黃帝內經·靈樞·營衛生會篇》指出：上焦如霧（指心肺的輸布作用），中焦如漚（指脾胃的消化轉輸作用），下焦如瀆（指腎與膀胱的排尿作用，並包括腸道的排便作用），這些功能實際就是體內臟腑氣化功能 的綜合。故三焦的功能，概括而言是受納水谷、消化飲食、輸送營養、排泄廢料。三焦的 "焦" 字，有熱的含義，這種熱來源於命門之火，是通過氣化的作用來體現的。三焦的功能是主管臟腑水液代謝的，可以使人體水液代謝正常、身體輕盈挺拔、真元之氣充盛、氣血運行暢通、保健臟腑。

Use the song to tell the children that by unblocking the triple energizer meridian and regulating San Jiao, it can improve the body's water-liquid metabolism, regulate the body's gasification function, and maintain the vitality of the body.

The "Huangdi Neijing·Lingshu·Yingwei Shenghui Pian" pointed out: the upper Jiao Ruwu (refers to the transfer effect of the heart and lungs), the middle Jiao Rufu (refers to the digestion and transfusion effect of the spleen and stomach), and the lower Jiao Rudu (refers to the kidney and bladder urination, including the bowel function of the intestine), these functions are actually the synthesis of the gasification function of the internal organs. Therefore, the functions of the San Jiao are to receive water, digest food, transfer nutrients, and excrete waste. The word "Jiao" in San Jiao has the meaning of heat. This heat comes from the fire of Mingmen and is reflected by the effect of gasification. The function of San Jiao is in charge of the visceral fluid metabolism, which can make the body's fluid metabolism normal, the body is light and straight, the vital energy is filled, the Qi and blood flow smoothly, and the viscera are healthy.

第三句 擎天柱地拔腰體

The third sentence Qing Tian Zhu Di Ba Yao Ti

用歌訣告訴小朋友們，該式動作主要強調上下對拔的 "托天" 動作 定勢。

無論是 "托天" 的正面定勢，還是 "托天" 的左右旋轉，練習時都要做到腳趾抓地，拔腰沈髖，幫助兩臂上撐頂腕，以達牽拉胸、腹等三焦部 位，刺激三焦經原穴 "陽池" 的目的，起到暢通三焦經絡、改善三焦功能、改善練習者水液代謝和氣化作用。

Use the song to tell the children that this movement mainly emphasizes the up and down counter-pull stop motion movement of "holding high".

Whether it's the "holding high" stop motion with body facing forward, or the left-right rotation of "holding high", when practicing, children must grasp the ground with their toes, pull the waist and sink the hip, and help the arms to support their wrists to stretch their chest and abdomen and to achieve the purpose of stimulating the San Jiao Jing Yuan point "Yang Chi", so as to unblock the San Jiao meridian, improve the function of the San Jiao, and improve the water-liquid metabolism and gasification of the children.

第四句　塑形強體添精神
The fourth sentence　Su Xing Qiang Ti Tian Jing Shen

用歌訣告訴小朋友們，通過該式練習，可以培養少年兒童正確挺拔的體姿，塑造優美矯健的身形，達到梳理關節、調節內臟、增強體質的健身效果，並可激發練習者朝氣蓬勃的精神面貌，達到改善氣質、提升正能量 的目的。

Use the song to tell the children that through practicing this movement, children can be trained to cultivate a correct and upright body posture, shape a beautiful and healthy body shape, achieve the fitness effect of combining joints, regulating internal organs, and enhancing physical fitness, and can stimulate the vigorous spirit of the children's appearances, in order to achieve the purpose of improving temperament and enhancing positive energy.

第二式【五勞七傷往後瞧】
Movement two 【Looking Backwards to Prevent Sickness and Strain】

第一句　大椎定喘藏頸肩
The first sentence　Da Zhui Ding Chuan Cang Jing Jian

用歌訣告訴小朋友們，大椎穴和定喘穴分布於人體的頸、肩結合部的 中央地帶。

Use the song to tell the children that the Da Zhui and Ding Chuan points are located in the central area of the neck and shoulder joints of the human body.

第二句　益氣通陽沖九天
The second sentence　Yi Qi Tong Yang Chong Jiu Tian

用歌訣告訴小朋友們，大椎穴和定喘穴是幫助練習者提升陽氣，幫助 氣血運行、增強體質的。

中醫認為，大椎穴是六陽經的總匯，是身體的強壯穴位，定喘穴則具 有"益氣通陽，宣肺平喘，退熱之虐，寧神豁痰"的功效，刺激大椎穴和 定喘穴，具有顯著的暢通督脈、提升人體陽氣、提高免疫力、強壯身體的 功能，進而培養練習者意氣風發、器宇軒昂、豪氣沖天的氣質。

Use the song to tell the children that Da Zhui and Ding Chuan points are to help them improve Yang Qi, help their Qi and blood flow, and strengthen their physical fitness.

Traditional Chinese medicine believes that Da Zhui point is the confluence of the six Yang meridians and is a strong point for the body. Ding Chuan point has the effects of "invigorating Qi and promoting Yang, promoting lung and asthma, relieving the abuse of fever, calming the mind and eliminating phlegm", stimulating Da Zhui point and Ding Chuan point, having a remarkable function of smoothing the supervisory channel, improving the body's Yang Qi, improving immunity, and strengthening the body, then cultivates the spirit of the children and the heroic temperament.

第三句　左顧右盼放眼望
The third sentence　Zuo Gu You Pan Fang Yan Wang

用歌诀告诉小朋友们，该式练习，主要强调通过左右大幅度转头、向远方眺望的方式，来加强对颈部肌肉的牵拉幅度，加大对大椎穴和定喘穴的刺激强度。

Use the song to tell the children that this movement mainly emphasizes that through turning the head left and right with a large margin and looking into the distance, children can strengthen their ability to stretch their neck muscles and increase the stimulation intensity of Da Zhui and Ding Chuan points.

第四句　神形疾患莫可犯
The fourth sentence　Shen Xing Ji Huan Mo Ke Fan

用歌訣告訴小朋友們，通過該式練習，可以有效地提升人體陽氣，改善兒童、青少年的兒免疫力，提高其新陳代謝水平，達到有效預防因為 "五勞七傷"所產生的身心疾病的目的。

Use the song to tell the children that through this practicing this movement, they can effectively enhance the body's Yang Qi, improve the immunity, and increase their metabolism, so as to effectively prevent physical and mental diseases caused by "five labors and seven injuries" (prevent sickness and strains).

第三式 【調理脾胃須單舉】

Movement three 【Holding One Arm Aloft to Regulate the Functions of the Spleen and Stomach】

第一句　脾胃後天定中原

The first sentence　Pi Wei Hou Tian Ding Zhong Yuan

用歌訣告訴小朋友們，脾為人體的 "後天之本"，脾胃位於各臟腑的 中央位置，稱 "中央戊己土"。

所有的生命活動都依賴於後天脾胃攝入營養物質供應能量。人作為獨立的個體而生存，主要靠脾來供給能量，故稱為後天之本、氣血生化之源。 其作用主要是提供運化水谷精微物質、充養腎精和生化氣血。中醫認為， 脾為五臟之一，與胃同受水谷，輸布精微，為生命動力之源。中醫學的脾， 除了包括現代醫學中消化系統的主要功能外，還涉及神經、代謝、免疫、 內分泌等系統的功能。

Use the song to tell the children that the spleen is the "native foundation" of the human body, and the spleen and stomach are located in the center of the viscera, which is called "Zhong Yang Shu Ji Tu".

All life activities depend on the acquired spleen and stomach ingesting nutrients to supply energy. Human beings live as independent individuals and rely mainly on the spleen to supply energy, so it is called the foundation of acquired nature and the source of Qi and blood. Its function is mainly to provide transportation and transformation of water and grain essence, nourish kidney essence and biochemical Qi and blood. Traditional Chinese medicine believes that the spleen is one of the five internal organs, which receives water and valleys together with the stomach, and is the source of life power. In addition to the main functions of the digestive system in modern medicine, the spleen in Chinese medicine also involves the functions of the nervous, metabolic, immune, and endocrine systems.

第二句　運化水谷血氣全

The second sentence　Yun Hua Shui Gu Xue Qi Quan

用歌訣告訴小朋友們，脾的功能是主運化、升清，主統血的，它負責消化吸收營養物質，並把營養物質輸布到全身各臟腑。

《醫宗必讀》說： "一有此身，必資谷氣，谷入於胃，灑陳於六腑而氣至，和調於五臟而血生，

而人資以為生者也, 故曰後天之本在脾。""脾胃為氣 血化生之源。"具體來說, 就是脾可以造血、儲血、濾血和攝血。脾胃功能的好壞, 直接關系到人體肌肉是否強壯, 有了脾胃的正常工作, 就能使 人獲得源源不斷的物質能量, 使身體氣血充盈, 能量充足, 肌體發育健康, 免疫功能增強。

Use the song to tell the children that the function of the spleen is to transport and transform, promote cleansing, and control the blood. It is responsible for digesting and absorbing nutrients and distributing nutrients to the viscera of the whole body.

"Yi Zong Bi Du" said, "If you have this body, you must be rich in Qi, and the Qi will enter the stomach, and will be poured into the six internal organs. Harmony is in the five internal organs and is born in blood, and the human resource is also the one who lives, so the foundation of the nurture lies in the spleen. " "The spleen and stomach are the source of Qi and blood metaplasia." Specifically, the spleen can produce blood, store blood, filter blood, and take blood. The function of the spleen and stomach is directly related to whether the human muscles are strong. With the normal work of the spleen and stomach, people can obtain a steady stream of material energy, so that the body is full of Qi and blood, sufficient energy, healthy body development, and enhanced immune function.

第三句　頂天立地撐與按
The third sentence　Ding Tian Li Di Cheng Yu An

用歌訣告訴小朋友們, 該式動作要做到, 在百會上頂、腳趾抓地的同時, 一臂上撐, 一臂下按, 好似擎天柱地一樣, 瀟灑大方, 豪邁霸氣, 以此來 達到"脾升胃降"、調理氣血的目的。

Use the song to tell the children that this movement should be done with Bai Hui point pulled to the top and the toes grab the ground, and at the same time the body is supported with one arm propped up and one arm pressed down, like Optimus Prime, chic and generous, bold and domineering, so as to achieve the purpose of "uplifting the spleen and lowering the stomach" and regulating Qi and blood.

第四句　氣血充盈身體健
The fourth sentence　Qi Xue Chong Ying Shen Ti Jian

用歌訣告訴小朋友們, 通過該式練習, 可以加強對脾胃經的刺激, 加 之配合深長的腹式呼吸, 又可加大膈肌的上下蠕動, 以加強對肝、脾、胃 的按摩, 從而可以有效地改善其血液循環, 調理脾胃、疏泄肝氣, 使身體 得到豐富營養, 發育良好, 肌肉強健, 身強體壯。

Use the song to tell the children that through practicing this movement, the stimulation of the spleen and stomach meridians can be strengthened, and when combined with deep abdominal

breathing, the upper and lower peristalsis of the diaphragm can be increased to strengthen the massage of the liver, spleen and stomach, which can be effectively improves blood circulation, regulates the spleen and stomach, relieves the Qi in the liver, so that the body is rich in nutrition, develops well, the muscles and the body is strong.

第四式【左右開弓似射雕】
Movement four 【Posing as an Archer Shooting Both Left- and Right-Handed】

第一句　肺為相傅曰華蓋
The first sentence　Fei Wei Xiang Fu Yue Hua Gai

　　用歌訣告訴小朋友們，肺屬"相傅之官"，是輔佐心的；又因為肺位置居於所有臟腑之上，其形似傘，所以中醫又稱其為"華蓋"。

　　《黃帝內經》說："肺者，相傅之官，治節出焉。"也就是說，肺相當於一個王朝的宰相，一人之下，萬人之上。宰相的職責是了解百官、協調百官，事無巨細都要管。所以肺必須了解五臟六腑的情況，並加以協調。《黃庭內景經·肝氣》說："坐侍華蓋遊貴京。"梁丘子註："華蓋肺也。"

Use the song to tell the children that the lungs are similar and belong to the "prime minister," they help the heart; and because of the location of the lungs is above all the viscera and looks like an umbrella, so it is also called "Hua Gai" (canopy over an imperial carriage) in Chinese medicine.

"Huangdi Neijing" said, " The lung is the organ similar to the prime minister and is responsible for management and regulation." In other words, the lung is equivalent to the prime minister of a dynasty, under one person and above 10,000 of people. The duty of a prime minister is to understand and coordinate with all officials, and to take care of everything. Therefore, the lungs must understand and coordinate with different situations of all internal organs. The "Huangting Neijingjing·GanQi" says, "Zuoshi Huagai You Guijing" Liang Qiuzi notes, "Huagai Feiye."

第二句　主司呼吸朝百脈

The second sentence　Zhu Si Hu Xi Chao Bai Mai

　　用歌訣告訴小朋友們，肺的功能是主管呼吸，主宰全身之氣的。另外，百脈都朝向於肺，肺是負責聯絡全身的血脈、控製全身經脈的開合節 律的，所謂"一吸百脈皆合，一呼百脈皆開"就是這個道理。

　　也就是說，肺是將呼吸之氣轉換為全身的一種正氣、清氣（吸入新鮮氧 氣，呼出二氧化碳），進而輸布到全身。《黃帝內經》中有"肺朝百脈，主治節"之說，即是說，肺是通過氣來調節治理全身的，全身各部的血脈都直接 或間接地會聚於肺，然後輸布到全身。當然肺還有主肅降、主皮毛之功能。

Use the song to tell the children that the function of the lungs is in charge of breathing and the Qi of the whole body. In addition, all the various meridians are directed towards the lungs. The lungs are responsible for connecting the blood vessels of the whole body and controlling the rhythm of opening and closing the meridians of the whole body.

In other words, the lungs convert breathing air into a kind of righteous and clear air (inhaling fresh oxygen and exhaling carbon dioxide), which is then delivered to the whole body. In the "Huangdi Neijing", there is a saying that "the lungs move towards hundreds of meridians and treat the Jie", that is, the lungs regulate and govern the whole body through Qi, and the blood vessels in all parts of the body directly or indirectly converge in the lungs, and then is transferred to the whole body. . Of course, the lungs also have the function of controlling Sujiang and fur.

第三句　彎弓射箭勤學練

The third sentence　Wan Gong She Jian Qin Xue Lian

　　用歌訣告訴小朋友們，只有通過勤學苦練，才能掌握高超的射箭本領； 因為，射箭的姿勢，引弓、拉弓和放箭的方法，要通過千錘百煉才能很好 地掌握，如"紀昌貫虱" 一樣。在此，也提示大家，做任何事都要勤學苦練，才能掌握知識，增長本領，成為國家、社會和家庭有用的人才。

　　紀昌貫虱：《列子·湯問篇》載，飛衛是古代射箭的高手。紀昌要向他學射箭，通過練 習三年眼力，虱子在他眼中就像是車輪。這時紀昌用硬弓勁箭射虱，能精確到"貫虱之心，而懸 不絕"。

Use the song to tell the children that only through hard study and practice can they master superb archery skills; because the archery postures, the methods of bow-drawing and arrow release can only be mastered through thousands of hard work, just like "Ji Chang Guan Shi". Here, also be reminded that everyone must learn and practice hard to do anything in order to master knowledge, increase skills, and become useful talents for the country, society, and family.

Ji Chang Guan Shi: In "Liezi·Tangwen Pian", Feiwei is a master of archery in ancient times and Ji Chang wants to learn archery from him. After three years of training his eyesight, louse are like wheels in his eyes. At this time, Ji Chang shot lice with a hard-bow and arrow, which could be accurate to the point of "Guan Shi Zhi Xin, Er Xuan Bu Jue".

第四句　豪氣雄姿育英才

The fourth sentence Hao Qi Xiong Zi Yu Ying Cai

用歌诀告訴小朋友們，通過該式練習，不僅可以有效地改善呼吸功能，調節周身氣血，達到增強體質的目的，還可以培養少年兒童英姿颯爽的體姿和器宇軒昂的氣質，使之成為建設國家、保衛國家的棟梁之材。

Use the song to tell the children that through practicing this movement, they can not only effectively improve their breathing function, regulate the Qi and blood of the whole body, and achieve the purpose of strengthening the physical fitness, but also cultivate the heroic posture and the exquisite temperament of the children, leading them to be the pillars of building and defending the country.

第五式【搖頭擺尾去心火】

Movement five【Swinging the Head and Lowering the Body to Relieve Stress】

第一句　心為君主地位尊

The first sentence Xin Wei Jun Zhu Di Wei Zun

用歌诀告訴小朋友們，心在各臟腑中地位最高、最尊貴，占據著最重要的位置，就好像一國之君一樣。

《黃帝內經·素問·靈蘭秘典論》曰："心者，君主之官，神明出焉。" 張景嶽註："心為一身之君......臟腑百骸，惟所是命，聰明智慧，莫不由之。" 心的功用是管理精神和血的，其他全身各部都歸心的領導，是心的 "臣民"。

Use the song to tell the children that the heart is having the highest, the most noble, and the most important position among the viscera, just like the king of a country.

"Huangdi Neijing·Suwen·Linglan Midian Lun" says, "Xin Zhe, Jun Zhu Zhi Guan, Shen Ming Chu Yan." Zhang Jingyue notes, "The heart is the monarch of the whole body... Hundreds of viscera listen to

the order of the heart, they cannot decide whether they are clever and wise or not." The function of the heart is to manage the spirit and blood, other organs in the whole body are also dedicated to the heart and are the "citizens" of the heart.

第二句　統領五臟益血神

The second sentence　Tong Ling Wu Zang Yi Xue Shen

用歌訣告訴小朋友們，心的生理作用是主血脈、主神誌，並且管理身 體的五臟六腑的工作。

其主血脈的良好作用在於使心氣充沛、血液充盈、脈道通利與完好三 個方面，進而使人氣血流通，精力充沛，身心健康，神采奕奕；反之則面 色無華、心前區疼和胸悶氣短。心主神誌的功能表現在心藏神，其功能正常則會使人精神振奮、神誌清晰、思維敏捷、反應靈敏；如心藏神的功 能異常，可出現失眠、多夢、健忘、神誌不寧，甚至昏迷、譫狂等臨床 表現。

Use the song to tell the children that the physiological function of the heart is to control the blood, the mind, and the work of managing the body's internal organs.

The good function of its main bloodline is to make the heart and Qi energize, blood full, pulse smooth and intact, and then to make the human blood circulate, energetic, physically and mentally healthy, and radiant; on the contrary, the complexion will be bleak, the heart will be painful, the chest will be tight and will feel of shortness of breath. The function of the mind-dominant mind is manifested in the mind-concealment of the mind. If its function is normal, it will make people excited, clear minded, quick thinking, and sensitive. If the function of the mind-keeping mind is abnormal, it may cause insomnia, dreaminess, forgetfulness, restlessness, and even clinical manifestations such as coma and delirium.

第三句　搖頭擺尾融心腎

The third sentence　Yao Tou Bai Wei Rong Xin Shen

用歌訣告訴小朋友們，通過加強"搖頭"和"擺尾"的鍛煉，並註意 兩者的協調配合，有助於調理脊柱，有效地改善腎功能，使心、腎關系 協調。因為調理脊柱，可有效刺激督脈，而"督脈貫脊屬腎"（《素問懸 解經絡論二十七》）。中醫有"腎屬水、心屬火，心腎相交、水火相（既）濟" 理論。

Use the song to tell the children that by strengthening the practice of "head shaking" and "tail waving", and paying attention to the coordination of this two movements, it helps to regulate the spine, effectively improve the function of the kidney, and harmonize the relationship between heart and kidney. Because it regulates the spine, it can effectively stimulate the meridian of Du Mai, and "the meridian of Du Mai runs through the spine of the kidney" ("Suwen Xuanjie · Meridian Theory 27").

Traditional Chinese medicine has the theory that "kidney belongs to water, heart belongs to fire, the heart and kidney intersect, and water and fire are mutually beneficial".

第四句　水火相濟寧身心
The fourth sentence　Shui Huo Xiang Ji Ning Shen Xin

用歌訣告訴小朋友們，通過心腎相融的練習，可以提腎水、降心火，使心主神誌、心主血脈的功能得到加強，從而獲得良好的益心智、行血氣、恬精神、培情誌之功效。

Use the song to tell the children that through the practice of heart-kidney harmony, they can raise their "kidney water" and lower the "heart fire", thus strengthen the function of the heart controlling the mind and controlling the blood, so as to gain a good mind, promote blood Qi, calm the spirit, and cultivate emotional efficacy.

第六式【攢拳怒目增氣力】
Movement six 【Thrusting the Fists and Making the Eyes Glare to Enhance Strength】

第一句　肝為將軍腎同源
The first sentence　Gan Wei Jiang Jun Shen Tong Yuan

用歌訣告訴小朋友們，肝為"剛臟"，在五臟中稱為"將軍之官"，並且"肝腎同源"，意即為肝、腎的結構和功能雖有差異，但其起源相同，生理病理密切相關，可采用"腎肝同治"的治療法則。

中醫認為，在先天，肝、腎共同起源於生殖之精；在後天，肝、腎共同受腎所藏的先天後天綜合之精的充養，"人始生，先成精，精成而腦髓生"（《黃帝內經·靈樞·經脈》）。"腎生骨髓，髓生肝。"（《素問·陰陽應象大論》）

Use the song to tell the children that the liver is the "Gang Zang", which is called "the general in an army" in the five internal organs, and "the liver and kidney are having the same origin", which means that although the structure and function of the liver and kidney are different, they have the same origin, their physiology and pathology are closely related, and the treatment rule of "kidney and liver treating

simultaneously" can be used.

Traditional Chinese medicine believes that in the innate, the liver and kidneys originate from the essence of reproduction; in the acquired days, the liver and kidneys are jointly nourished by the congenital and acquired comprehensive essence of the kidneys. "Humans are born, first become refined, then brains are born" ("Huangdi Neijing·Lingshu·Jingmai"). "The kidneys produces bone marrow, and the marrow produces liver." ("Suwen·YinYang Yingxiang Dalun")

第二句　主筋通目智勇全
The second sentence　Zhu Jin Tong Mu Zhi Yong Quan

肝開竅於目，在體合筋，主管調節和貯藏全身血液，還是人體智力、 勇猛頑強精神的物質基礎。

中醫認為，肝功能一主疏泄，表現在疏通調暢全身氣血、協調情誌 活動、協助脾胃運化水谷、協助排泄男子的精液和女子的經血; 二主 藏血，是說肝臟有貯藏血液、調節周身血量的功能。 "（肝）主春生之氣， 潛發未萌，故謀慮出焉。" 故肝氣調暢，可使氣血舒展，各臟腑器官機能正常，使人身體健康，肝功能的正常，也可使人腎氣充盛，思維敏捷， 記憶力倍增。

The liver resuscitates the eyes, the body combines tendons, regulates and stores blood throughout the body, and is the material basis of human intelligence and bravery and tenacious spirit.

Traditional Chinese medicine believes that liver function is the primary function of dredging, which is manifested in dredging and regulating the Qi and blood of the whole body, coordinating emotional activities, assisting the spleen and stomach to transport water and valley, assisting in excretion of men's semen and women's menstrual blood; the second principle is to store blood, which means that the liver has the function of storing blood and regulating the blood volume of the whole body. "(Liver) controls the Qi of spring, the spirit of the main spring has not sprouted, so the plan is out of it. " Therefore, the Qi in the liver can be adjusted, which can stretch the Qi and blood, and the functions of various viscera and organs can be normal, so that the body is healthy, and the liver function is normal. It makes people full of Qi in kidney, having quick thinking, and double memory.

第三句 怒目沖拳吼聲震

The third sentence Nu Mu Chong Quan Hou Sheng Zhen

用歌訣告訴小朋友們，該式動作的要領，是在沖拳的同時要強調怒目瞪視前方，並且同時發出響亮的"哈哈"的聲音，以契合"肝為 將軍之官"的特點，達到疏泄肝氣、提振精神、培養勇猛頑強精神的目的。

Use the song to tell the children that the key to this movement is to stare at the front while punching the fist, and at the same time make a loud "haha" sound, in order to fit the characteristics of "the liver is the general of an army", and achieve the purpose of sparseness, venting the liver, boosting the spirit, and cultivating the brave and tenacious spirit.

第四句 武穆精神永流傳

The fourth sentence Wu Mu Jing Shen Yong Liu Chuan

用歌訣告訴小朋友們，從小通過學練八段錦，來提高努力學習、苦練本領的積極性和自覺性，進而獲得學習、強體和堅定愛國信念的良好收獲， 為將來成為建設國家、保衛國家的棟梁之材服務。

武穆是民族英雄嶽飛的謚號，資料記載，當年嶽家軍為了強健士兵的 身體，更好地抗擊金兵，在軍中大力推廣八段錦。

Use the song to tell the children that by learning and practicing Ba Duan Jin from an early age, they can improve their enthusiasm and consciousness to study hard and practice hard, and then gain good results in learning, strengthening their body, and firm their patriotic beliefs, and serve as a pillar of the country's construction and defense in the future.

Wu Mu is the posthumous title of the national hero Yue Fei. According to data, the Yue family army vigorously promoted Ba Duan Jin in the army in order to strengthen the soldiers' body and fight against the foreign (Jin Bing).

第七式【雙手攀足固腎腰】

Movement seven 【Moving the Hands down the Back and Legs, and Touching the Feet to Strengthen the Kidneys】

第一句　腎為先天戍邊軍

The first sentence　Shen Wei Xian Tian Shu Bian Jun

用歌訣告訴小朋友們，腎是人體先天之本，是我們生命和健康的保 護神。

《黃帝内經 ·靈樞 ·決氣》說："兩神相搏，合而成形，常先身生，是 謂精。" 也就是說 "精" 早於人的身體。中醫有 "腎氣免疫學說"。一般來說， 人體衰老會引起腎氣虛衰、免疫力下降，導致各種慢性病甚至癌癥的滋生，因此，腎在人的生命和臟腑健康中扮演的是防護、保衛的角色。

Use the song to tell the children that the kidney is the innate foundation of the human body and the protector of their lives and health.

The "Huangdi Neijing · Lingshu · Jue Qi" says, "Liang Shen Xiang Bo, He Er Cheng Xing, Chang Xian Shen Xian, Shi Wei Jing." That is to say, "Jing" predates the human body. Traditional Chinese medicine has "theory of kidney Qi immunity". Generally, aging of the human body will cause the deficiency of the Qi in kidney and the decline of immunity, leading to the growth of various chronic diseases and even cancer. Therefore, the kidney plays a role of protection and defense in human life and visceral health.

第二句　主骨生髓藏精魂

The second sentence　Zhu Gu Sheng Sui Cang Jing Hun

用歌訣告訴小朋友們，腎的功能是主骨、生髓、健腦的，它的健康與否， 直接關系到骨骼的強壯、精力的充沛和大腦的聰慧與否。

另外，腎氣主宰人體生、長、壯、老、已，掌控臟腑、骨骼、發膚、生殖的健康。腎精足，自然精力充沛，神思敏捷，記憶力增強，筋骨強健， 行動輕捷。腎是人體精力強盛的源泉，腎氣充盈能讓人精神煥發、聰明智慧。

Use the song to tell the children that the function of the kidney is to manage bones, grow marrow, and strengthen the brain. Its health is directly related to the strength of the bones, the fullness of energy, and the intelligence of the brain.

In addition, the Qi in the kidney controls the birth, growth, strength, old, and death of a human body, and controls the health of viscera, bones, hair and skin, and reproduction. When the kidney is full of energy, it will be natural energetic, mental agile, and memory will be enhanced, muscles and bones will be strong, and the movement will be light and agile. The kidney is the source of the human body's energy, and the fullness of Qi in kidney can make people refreshed and wise.

第三句　俯身攀足頻蹲起
The third sentence　Fu Shen Pan Zu Pin Dun Qi

用歌訣告訴小朋友們，該式練習，要大幅度地做體前屈的俯身動作和全蹲的練習，來達到鍛煉腰腿力量，拉伸背後肌群，以便於強壯腰腹、改善背後肌群柔韌性和暢通膀胱經的目的。

Use the song to tell the children that practicing this movement requires large-scale forward bending and full squatting exercises so as to achieve the purpose of practicing the strength of the waist and leg, stretching the back muscles, strengthening the waist and abdomen, in order to strengthen the waist and abdomen, improve the flexibility of the back muscles and unblock the bladder meridian.

第四句　強骨增力智常新
The fourth sentence　Qiang Gu Zeng Li Zhi Chang Xin

用歌訣告訴小朋友們，通過該練習，可以達到強壯筋骨、增強力量和 改善智力的目的。

《黃帝內經 ·素問 ·靈蘭秘典論》說： "腎者，作強之官，伎巧出焉。" 這是指腎的主要功能是主宰人體骨、生殖泌尿、腦等健康的。 "腎主骨、 生髓" "腦為髓之海" （《黃帝內經 ·靈樞 ·海論》），腎精充盛，自然使筋骨 強健，精力充沛，同時還會神思敏捷，記憶力增強，行動輕捷，聰明智慧。

Use the song to tell the children that through practicing this exercise, they can achieve the purpose of strengthening their bones and strength, and improving their intelligence. "Huangdi Neijing·Suwen·Linglan Midian Lun" says, "Shen Zhe, Zuo Qiang Zhi Guan, Ji Qiao Chu Yan." This means that the main function of the kidney is to control the health of the human bone, genitourinary and brain. "Kidney governs bones and produces marrow" and "brain is the sea of marrow" ("Huangdi Neijing·Lingshu·Hailun"). The kidneys are full of essence, which naturally makes the bones and muscles strong and energetic. At the same time, it will make the mind agile, enhance memory, act lightly, and be smart and wise.

第八式【背後七顛百病消】
Movement eight 【Raising and Lowering the Heels to Cure Diseases】

第一句 經絡處處通身心
The first sentence Jing Luo Chu Chu Tong Shen Xin

　　用歌訣告訴小朋友們，經絡在人體中是極其豐富的，也是無處不至的，而且它是人體氣血運送的通道，是保障人體身心健康和成長的生命線，我們要好好地呵護它。

　　中醫認為："經絡是人體氣血運行的通道，它內聯臟腑，外絡肢節，正常情況下氣血運行是無處不至的。人體六臟六腑各有一條經絡，稱十二正經。如果因為某種原因，使某條經絡不通，就會導致臟腑得病；反之，如 果某個臟腑得病，也會導致所屬的經絡不通。"因此，確保生命健康的核心是經絡暢通。在《黃帝內經·靈樞·經脈》中有"經絡者，所以處百病，決生死，調虛實，不可不通"的記載。

Use the song to tell the children that the meridian is extremely rich in the human body, and it is everywhere. Moreover, it is the channel for the transportation of human Qi and blood and is the lifeline to protect the physical and mental health and growth of the human body, we must take good care of it.

Traditional Chinese medicine believes, "The meridian is the channel for the body's Qi and blood runs. It connects the internal organs and external collateral limbs. Under normal circumstances, the circulation of Qi and blood is ubiquitous. Each of the six internal organs of the human body has one meridian, which is called Shier Zhengjing. If for some reasons, a certain meridian is blocked, it will cause disease in the viscera; on the contrary, if a certain viscera is diseased, it will also cause the meridian to be blocked." Therefore, the core of ensuring life and health is unblocking meridian. In the "Huangdi Neijing·Lingshu·Jingmai", there is a record that "Jingluo zhe, suoyi chu baibing, jue shengsi, tiao xushi, buke butong".

第二句　運送氣血濡形神

The second sentence　Yun Song Qi Xue Ru Xing Shen

用歌訣告訴小朋友們，經絡是負責運送氣血到全身各部的，經絡暢通 就可以保證臟腑功能正常，就可以濡養身體內外、四肢百骸、筋骨皮肉及 心神意念；反之，就會導致臟腑功能下降，甚至產生疾病，身體和精神受 到傷害。所謂 "通則不痛，不痛則通" 就是這個道理。

Use the song to tell the children that the meridian is responsible for transporting Qi and blood to all parts of the body. The smooth flow of the meridian can ensure the normal function of the viscera, and can nourish the body's internal and external functions, limbs, bones, muscles, bones, flesh, and mind; On the contrary, it will lead to a decline in the function of the viscera, and even diseases, and physical and mental damage. This is the principle so-called "Tong Ze Bu Tong, Bu Tong Ze Tong".

第三句　提踵顛足調百脈

Ti Zhong Dian Zu Tiao Bai Mai

用歌訣告訴小朋友們，通過提踵和適度的振腳，可以有效地刺激全身經絡，啟動內氣，促進經絡暢通，改善氣血運行，達到身心健康的目的。

Use the song to tell the children that by raising the heels and moderately stamping the feet, it can effectively stimulate the meridians of the whole body, activate internal Qi, promote the smooth flow of the meridians, improve the circulation of Qi and blood, and achieve the purpose of physical and mental health.

第四句　根深葉茂煥青春

Gen Shen Ye Mao Huan Qing Chun

用歌訣告訴小朋友們，從小要樹立遠大的理想，涵養道德情操，要加強 鍛煉、刻苦學習，要不斷地增進知識、提高技能、紮紮實實地打好為祖國 建功立業的基礎，使自己的青春年華煥發出絢麗的光彩。

Use the song to tell the children that they should establish lofty ideals and cultivate moral sentiments since childhood, strengthen their practice, study hard, continuously improve knowledge and skills, and lay a solid foundation for the motherland to make contributions to the motherland, so that their teenage-youth will be glowing brilliantly.

第三章
少兒八段錦基礎

Chapter Three
Basic Techniques of Ba Duan Jin
for Children

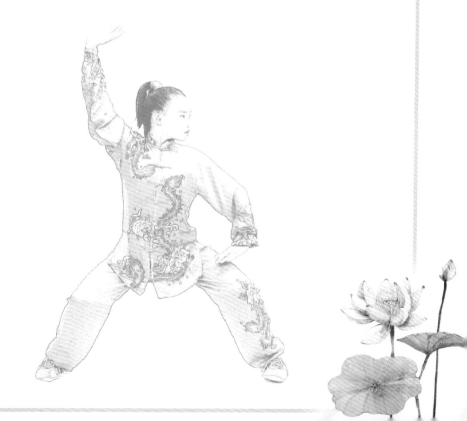

第一節　基本手型　Section One　Basic Hand Forms

一、拳 1. Fist

基本方法 Basic methods

四指並攏卷握，拇指扣在食指、中指的第二節指上。（圖 3-1）

Curl the four fingers together, buckle the thumb on the second section of the index finger and the middle finger. (Fig. 3-1)

圖 3-1

基本要求 Basic requirements

握拳手指要依次卷指緊扣，拳面要平，手腕要直，所有指關節外脹有勁力，中指點扣勞宮穴。

The fingers of a fist should be rolled and clasped in turn, the face of the fist should be flat, the wrist should be straight, all knuckles should be swelled with strength, and the middle finger should be buckled at the acupoint of Laogong.

註意預防 Avoidance

拇指上翹，拳面不平，握拳一把抓，未依次卷指，松弛無力，關節和拳體無外脹感。

The thumb is turned up, the fist is uneven, the fist is clenched, the fingers are not rolled in turn, without any strength, and there is no swelling in the joints and the fist.

糾正方法 Correction methods

強調依次卷指，所有指關節扣緊。握拳時，指節內卷，勁力外張。

Emphasize on rolling the fingers in turn, all knuckles are buckled. When making a fist, the knuckles are rolled inward and the force is stretched outward.

二、瓦楞掌 2.Waleng palm

基本方法 Basic methods

五指自然伸直，大小魚際稍裏合，掌心 微含，食指微後挑，其余三指稍向前。（圖 3-2）

The five fingers should be straightened naturally, big Yuji and small Yuji (thenars) are slightly closed inward, the palm is slightly closed, the index finger is slightly raised backward, and the remaining three fingers are slightly faced forward. (Fig. 3-2)

圖 3-2

基本要求 Basic requirements

手指自然伸直，不僵不拘，食指商陽穴感覺發脹，掌指溫暖舒適。

Straighten the fingers naturally, do not stiff, the index finger and the acupoint Shangyang should be swelled, the palm fingers should be warm and comfortable.

注意预防 Avoidance

手指過於僵直緊靠，掌面平直，掌指發涼。

Fingers are too stiff and closely placed together, the palm is flat and straight, and the palm fingers are cold.

糾正方法 Correction methods

放松掌指，大小魚際稍對合，盡量體會手掌溫熱。

Relax the palm fingers, big Yuji and small Yuji are slightly aligned, try to feel the warmth of the palm.

三、八字掌 3. L-shape palm

基本方法 Basic methods

拇、食指伸直，虎口撐開，其余三指所有指關節彎曲內扣。（圖 3-3）

Straighten the thumb and index finger, outstretch the tiger's mouth (Hukou), bend and buckle all the knuckles of the other three fingers inward. (Fig. 3-3)

基本要求 Basic requirements

食指和拇指充分伸直，少商穴、商陽穴酸脹感覺較強，其余三指指關節內扣外撐，勁力充分。

The index finger and thumb are fully extended, the acupoints of Shaoshang and Shangyang have a strong sense of soreness and expansion, the remaining three finger joints are buckled inward and stretched outward, with sufficient strength.

注意預防 Avoidance

拇指、食指松弛彎曲，虎口松弛，未能撐圓，指關節內扣無力，掌指關節隨之彎曲。

The thumb and index finger are loose and bent, the tiger's mouth is loose and cannot encircle, the knuckles are weak when buckling, and the metacarpophalangeal joints are bent.

纠正方法 Correction methods

強調拇指、食指撐直，虎口撐開；指關節彎曲時，要有向外的撐勁。

Emphasize that the thumb and index finger should be straightened, and the tiger's mouth should be stretched; when the knuckles are bent, there should be an outward bracing.

圖 3-3

四、拉弓勾（龍爪） 4. Lagong hook (Dragon paw)

基本方法 Basic methods

在瓦楞掌的基礎上，五指所有指骨間關節同時彎曲內扣成勾。（圖 3-4）

On the basis of the Waleng palm, all the interphalangeal joints of the five fingers bend and buckle into a hook at the same time. (Fig. 3-4)

基本要求 Basic requirements

扣指時，各指骨間關節盡量外撐，勁力飽滿。

When buckling the fingers, the joints between the phalanges should be outward expanded as much as possible with full strength.

注意預防 Avoidance

指間關節內扣無力，掌指關節隨 之彎曲。

The interphalangeal joints are weak when buckling, and the metacarpophalangeal joints and palm fingers are bent.

纠正方法 Correction methods

扣指時，所有指間關節外撐。

When buckling the fingers, all the interphalangeal joints outstretched.

圖 3-4

第二節　基本步型　Section Two　Basic Step Form

一、馬步 1.Horse Stance

基本方法 Basic Methods

兩手叉腰（或抱拳）於腰間；兩腳左右分開，屈膝半蹲，重心在 中間，兩腳之間的距離約為腳長的 3 倍半，腳尖向前微內扣，大腿約 平行地面；眼視前方。（圖 3-5）

Keep both hands akimbo (or hold fists) at the side of the waist; separate both feet to the left and right, bend the knees and semi-squat with the center of gravity in the middle. The distance between the feet is about three and a half times the length of the feet. The toes are slightly buckled inward, and the thighs are about parallel to the ground; look forward. (Fig. 3-5)

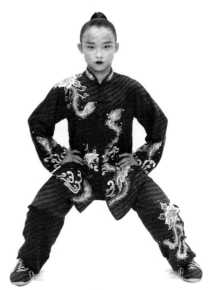

圖 3-5

注意預防 Avoidance

聳肩縮脖，挺胸塌腰，撅臀跪膝，腳尖外撇。

Shrugging and shrinking the neck, chest out and waist sunk, pouting hips and kneeling knees, tiptoes stretched outward.

纠正方法 Correction methods

強調欲拔頂先沈肩，欲下蹲先沈髖，欲沈髖先落臀。

Emphasize on sinking the shoulders if the purpose is to pull up, sinking the hips if the purpose is to squat, and sinking the hipbones if the purpose is to sink the hips.

二、弓步 2.Bow Stance

基本方法 Basic methods

兩手叉腰於腰間（或抱拳）；兩腳前後分開，前腿弓、後腿蹬，重心為前腿承擔約 2/3，後腿承擔約 1/3，前後距離約為腳長的 4 倍，左右距離 約為 15 厘米。前腳腳尖向前微內 扣，大腿前弓約與地面 平行；後腳 腳尖裏扣，斜向前約 45°，後腿 蹬直；上體直立朝前（稍傾），眼 視前方。（圖 3-6）

Keep both hands akimbo (or hold fists) at the side of the waist; separate both feet with one foot placed forward and the other placed backward, bow the front leg and stretch the back leg. About 2/3 of the center of gravity is on the front leg and about 1/3 of the center of gravity is on the back leg. The vertical distance between two feet is about 4 times of the length of the foot, the horizontal distance between two feet is about 15 cm. The tiptoes of the front foot are slightly buckled inward, and the bow of the front thigh is approximately parallel to the ground; the tiptoes of the back foot are buckled inward with about 45 degrees diagonally forward, the back legs are straightened; the upper body is upright and facing forward (slightly inclined), look forward. (Fig. 3-6)

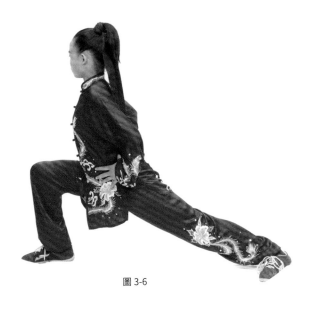

圖 3-6

基本要求 Basic requirements

前弓後蹬充分，身體中正，重心穩沈。

The front leg is fully bowed and the hind leg is fully stretched, the body is upright centered, and the center of gravity is stable.

注意预防 Avoidance

動作幅度過小，身體前傾後仰，弓腿膝關節前跪，膝關節未對腳尖，後膝過於松弛或過於僵直。

The movement range is too small, the body is leaning forward and backward, the joint of the front leg is kneeling forward when bowing, the knee joint is not facing the tiptoes, the knee of the back leg is too loose or too stiff.

纠正方法 Correction methods

明確概念，加強練習，增強腿部力量。前移重心時註意沈髖、拔頂、沈肩。

Clarify the concept, strengthen practices, and enhance the strength of the leg. Pay attention to sinking the hipbones, topping, and sinking the shoulders when moving the center of gravity forward.

三、橫襠步 3.Side bow stance

基本方法 Basic methods

兩手抱拳於腰間（或叉腰）；身體半面右轉，繼而回轉 90°使身體半面向左。兩腳斜方向前後分開，後腳 朝斜後方 45°方向；前後距離 3 腳半；前腿蹬直腳尖向前，後腿向後弓出，腳尖斜向後，左腿與地面平行。重心下沈前 3 後，身體後傾約 45°。眼視前外上方 45°方向。（圖 3-7）

Keep both hands akimbo (or hold fists) at the side of the waist; turn half of the body to the right, and then turn 90 degrees to the left so that half of the body faces left. Separate both feet obliquely with one foot placing forward and the other placing backward, the back foot facing the obliquely rearward 45 degrees; the vertical distance between both feet is three and a half feet; the front leg is stretched and straightened with the tiptoes facing forward, the hind leg is bowed backward with the tiptoes placed diagonally backward, the left leg is parallel to the ground. Sink the center of gravity, lean back about 45 degrees. Look forward of 45 degrees.

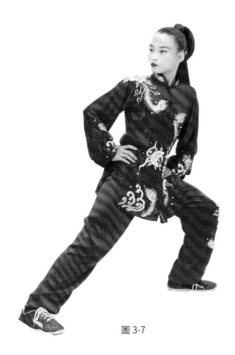

圖 3-7

基本要求 Basic requirements

前蹬後弓充分，沈髖後傾，保持 斜中正。

The front leg is fully stretched and the hind leg is fully bowed, sink the hips and lean back, keeping the center of gravity diagonally righteous.

注意預防 Avoidance

動作幅度過小，重心不穩身體歪 斜，後腿跪膝，膝蓋未對準腳尖，前腿蹬伸無力。

The movement range is too small, the center of gravity is unstable, the body is tilted, the hind leg is kneeling, the knee is not aligned with the tiptoes, and the front leg is weak when stretching.

纠正方法 Correction methods

明確概念，加強練習，提高腿部力量。後移重心時註意沈髖，固定脊柱。

Clarify the concepts, strengthen practices, and improve the strength of the legs. Pay attention to sinking the hips when shifting the center of gravity backward, fix the spine.

四、獨立步 4. Single leg stance

基本方法 Basic methods

兩手抱拳於腰間（或叉腰）；一腳站穩支撐，一腳提膝過腰，腳面繃直；
眼視前方。（圖3-8）

Hold fists with both hands (or keep both hands akimbo) at the side
of the waist; stand firmly and stably to give support to the body with
one foot, and raise the other knee over the waist with the other foot,
stretch the face of the foot straightly ; look forward. (Fig. 3-8)

基本要求 Basic requirements

沈肩拔頂，沈髖提腰，支撐腿松膝，似直非直，腳趾抓地。

Sink the shoulders and pull the top, sink the hips and raise the waist,
loose the knee of the supporting leg, seeming to be straight and also
not to be straight, the toes grip the ground.

注意預防 Avoidance

聳肩縮項，腰膝松軟，低頭駝背，身歪體斜，前後晃動。

圖 3-8

Shrugging the shoulders and shrinking the neck, loose the waist and knees, bow the head and
having hunchback, slanted body, and swaying back and forth.

纠正方法 Correction methods

增強腿部力量，註意沈髖提頂。先升支撐腿後撞提起腿，提腿先靠後提，盡量直上直下，腳趾抓地。

Enhance the strength of the legs, pay attention to sinking the hip and lifting the top. Raise the
supporting leg first, then lift the knee of the other leg. Lean the leg backward first when lifting
it, try lifting the leg up and down aligned and as vertical as possible, with the toes gripping the
ground.

第四章
少兒八段錦套路

Chapter Four　Standing Routine
of Ba Duan Jin for Children

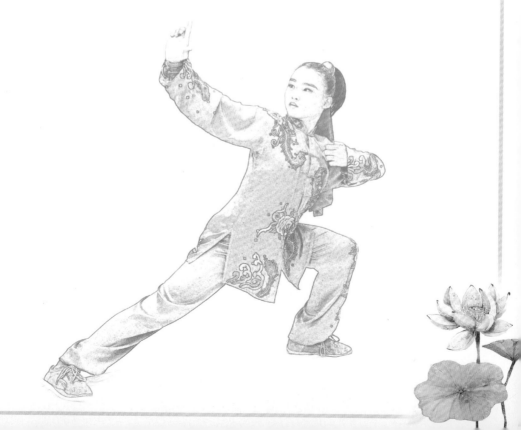

起 勢　Starting Form

並步站立，腳尖向前；兩掌垂於體側，兩中指腹分別貼於風市（褲縫 處）；目視前方。（圖 4-1）

Stance with feet together; tiptoes point to the front; both palms straight down by to both sides, middle fingers of both palms attach to Fengshi (seams of a trouser leg); look forward. (Fig. 4-1)

练习方法 Practice methods

第一拍：兩腳不 動；隨吸氣，兩臂內 旋外擺於體側，勞宮與腰同高，掌心向後斜向上；眼視前 方。（圖 4-2）

The first beat: Do not move both feet; along with inhalation, rotate both arms inward and swing them outward and place them to the side of the body along, Laogong acupoint is at the same height as the waist, and the center of the palms are tilted backwards and upwards; look forward. (Fig. 4-2)

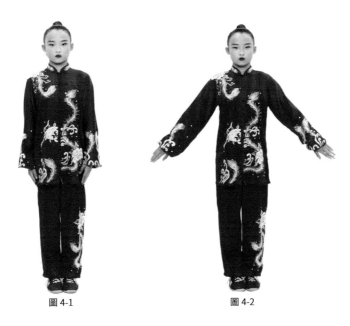

圖 4-1　　　　　　　　　　圖 4-2

第二拍：兩腳不動；兩臂外旋，兩掌內合疊於腹部，左掌在下，勞宮對準丹田；眼視前方。（圖 4-3、圖 4-4）

入靜 3~6 秒後，將兩掌緩緩垂落於體側；還原成並步站立式；眼視前方。（圖 4-5）

The second beat: Do not move both feet; rotate both arms outwards, fold both palms inward together on the belly, with the left palm at a lower position, the acupoint Laogong is aiming at the Dantian; look forward. (Fig. 4-3, Fig. 4-4)

After three to six seconds of calmness, slowly drop both palms on the side of the body; return to the spread feet stance standing posture; look forward. (Fig. 4-5)

練習次數 Number of practice

一吸一呼為一次，共做 1 次。

One inhale and one exhale are counted as once, in total do once.

練習要領 Practice essentials

（1）姿勢：百會上領，面部放松，舌頂上腭，嘴唇輕閉，下頦微收，頸項豎直；沈肩松肘，胸部微含，腹部微收，沈髖松膝，腳趾抓地。

（2）動作：旋臂充分，柔緩圓勻，舒展大方，找準穴位。

（3）呼吸：悠勻細緩，自然流暢。

（4）思想：集中安詳，怡然自得。

(1) Posture: Pull the acupoint Baihui to the top, relax the face, place the tongue on the palate, lightly close the lips, slightly retracted the chin, upright the neck; when sinking the shoulders and losing the elbows, slightly close the chest, and slightly retract the belly, sink the hipbones and loose the knees, the toes grip the ground.

(2) Movement: fully swing both arms, gently round and even, stretch generously, and pinpoint the acupoints accurately.

(3) Breathing: smooth, natural and gentle.

(4) Thought: Concentrate and be peaceful, comfortable and contented.

注意防范 Avoidance

（1）撞頭挺胸，伸臂直膝，塌腰腆腹。

（2）擺臂聳肩提肘，動作忽快忽慢。

（3）呼吸急促，註意力分散。

(1) Raise the head and chest out, stretch the arms and straighten the knees, and collapse the waist and the belly.

(2) The movements are sometimes fast and sometimes slow when swinging both arms, shrugging the shoulders, and lifting the elbows.

(3) Shortness of breath and distraction of mind.

练习作用 Practice effects

（1）端正身型，矯正體態，放松全身，促進血液循環。

（2）調勻呼吸，集中思想。

（3）為進一步練習做好準備。

(1) Righteous body shape, correct posture, relax the whole body, and promote blood circulation.

(2) Adjust breathing and concentrate thought.

(3) Be prepared for further practice.

圖 4-3 圖 4-4 圖 4-5

第一式　兩手托天理三焦
Movement One Holding the Hands High with Palms Up to Regulate the Internal Organs

练习方法

预备式: 接前式。

Practice methods

Preparation form: follow the previous movement

第一拍　The first beat

詠唱歌訣 "三焦通行上中下"。

隨吸氣，兩腳不動;兩掌腹前交叉，掌心向上，距離腹部小指側 5~10 厘米;眼視前 方（圖 4-6）。繼而,

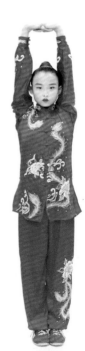

圖 4-6　　　　　圖 4-7　　　　　圖 4-8

兩掌上托，經面前翻掌上撐於頭頂，將頭擡起；眼視兩掌（圖 4-7）。 不停，兩掌繼續上撐頂腕，將頭回正；眼視前方，稍停約 2 秒。（圖 4-8）

Sing the lyrics "San Jiao Tong Xing Shang Zhong Xia".

Along with inhalation, keep both feet still; cross both palms in front of the abdomen, with the center of palms facing up, the side of the little fingers should be 5-10 cm from the abdomen; look forward (Fig. 4-6). Then, hold the two palms up, flip the palms through the face and hold them on the top of the head, lift the head up; look at the two palms (Fig. 4-7). Do not stop with a still position, keep propping the wrists of the palms to the top, turn the head to the righteous position; look forward and hold on about two seconds. (Fig. 4-8)

第二拍 The second beat

詠唱歌訣 "通調水道行元真"。

隨呼氣，上撐不動；將身體向左後大幅度轉動；眼視右後方，稍停約 2 秒。（圖 4-9）

Sing the lyrics "Tong Tiao Shui Dao Xing Yuan Zhen"

Along with exhalation, hold on propping without moving; turn the body to the rear left with a large motion; look to the rear right, slightly hold on about two seconds. (Fig. 4-9)

第三拍 The third beat

詠唱歌訣 "擎天柱地拔腰體"。

隨吸氣，兩掌上撐不動；將身體轉正；目視前方，稍停約 2 秒。（圖 4-10）

Sing the lyrics "Qing Tian Zhu Di Ba Yao Ti"

Along with inhalation, hold on propping without moving; turn the body to the righteous position; look forward, slightly hold on two seconds. (Fig. 4-10)

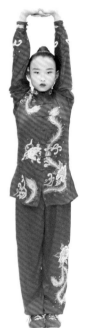

圖 4-9 圖 4-10

第四拍 The fourth beat

詠唱歌訣 "塑形強體添精神"。

圖 4-9 圖 4-10

隨呼氣，兩腳不動；兩掌分開，兩臂從身體兩側外分接沈肩墜肘，下按於體側（圖 4-11）；還原成並步站立式；眼視前方。（圖 4-12）

第五拍至第八拍，重復第一拍至第四拍，唯轉體方向相反。做完後，還原成並步站立式。

Sing the lyrics "Su Xing Qiang Ti Tian Jing Shen".

(Fig. 4-9) (Fig. 4-10)

Keep both feet still along with breathing; separate both palms, sink the shoulders and drop and elbows from the sides of the body with both arms, press them downward on the sides (Fig. 4-11); return to the stance with feet together; look forward. (Fig. 4-12)

From the fifth to the eighth beat, repeat the first to the fourth beat, except that the direction of rotation is opposite. After finishing, revert to the stance with feet together.

练习次数 Number of practice

可做 1 ～ 2 個八拍。

Do one to two eight-beat.

练习要领 Practice essentials

（1）動作柔和緩慢，動靜相間。撐臂上下保持在一個垂面上，動作疏 松，拔腰頂肩撐腕，腳趾抓地。

（2）轉體時，身體中正，腳底踏實，以眼帶體，轉體充分。 圖 4-12

（3）擡頭，下頦領先，似小鳥飲水，弧形上揚。

（4）呼吸自然深長，不要憋氣，思想集中在頂腕和脊柱的節節擰拉上，用意不用力。

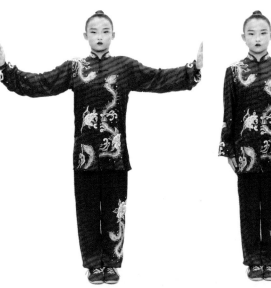

圖 4-11 圖 4-12

(1) The movements should be gentle and slow, with both active and static movements. Keep the arms on a vertical surface when propping them up and down. The movements should be loose, pull the waist and shoulders, prop the wrists, and grasp the ground with the toes.

(2) When turning the body, the body should be centered and the soles of the feet should be firm.

Use the eyes to bring the body, turn the body fully. (Fig. 4-12)

(3) Raise the chin first when raising the head, like a bird drinking water, arching upwards.

(4) Breath naturally and deeply, do not hold the breath. Focus on pulling the top wrist and spine, use the mind but not the force.

注意防范 Avoidance

（1）動作過快、過猛。上撐時松懈斷勁，身體後仰，力散於肘。轉體時腳底不穩。

（2）撐臂轉體用力太過，且僅用蠻力、拙力。

（3）擡頭仰體，轉體歪身，上托撐臂，未走直線。

(1) The movement is too fast or too violent. Loose and relax the force when propping the arms, the body is leaning back, and the force is scattered on the elbows. The soles of the feet are unstable when turning.

(2) Too much force is used in the rotation of the body and the prop of the amrs, and only brute force and clumsy force are used.

(3) Raise the head and body, turn around and tilt the body, lift up the arms in curved line.

練習作用 Practice effects

（1）大幅度托天撐臂，可牽拉全身關節，改善腰、肩、腕的柔韌性，幫助塑形美體，塑造完美體姿，使其朝氣蓬勃。

（2）擎天柱的擰轉，可改善上肢、軀幹各關節周圍肌肉、韌帶的血液循環，調理脊柱，預防頸肩腰痛。

（3）強調撐臂頂腕，有助於刺激陽池穴 ，牽拉上中下三焦部位，通 暢三焦經，促進水液代謝正常和全身氣血充盛。

(1) A large range of holding up and prop up can stretch the joints of the whole body, improve the flexibility of waist shoulder, and wrists, shape the body,and make a perfect body posture, and promote vigorous growth for children.

 (2) The rotation of Qing Tian Zhu can improve the blood circulation of the muscles and ligaments around the joints of the upper limbs and trunk, regulate the spine, and prevent neck, shoulder and low back pain.

(3) Emphasizing the prop up of arms and wrists is helpful to stimulate the acupoint Yangchi, stretch the upper, middle and lower triple burnt parts, unblock the Sanjiao meridian, and promote normal water metabolism and full body blood.

第二式　五勞七傷往後瞧
Movement Two Looking Backwards to Prevent Sickness and Strain

练习方法 Practice methods

預備式：接前式。

Preparation form: follow the previous movement

第一拍 The first beat

詠唱歌訣 "大椎定喘藏頸肩"。

隨吸氣，左腳向左開步站立，比肩稍寬，腳尖向前；同時，兩臂 弧形上擺至體前，掌心相對，與胸（膻中穴）同高，與肩同寬；眼視 前方（圖 4-13）。不停，隨呼氣，兩肘下沈，帶動兩臂回收於肩前（也可拇指腹分別點於雲門穴），勞宮穴相對，與雲門穴同高；眼視前方。（圖 4-14）

Sing the lyrics "Da Zhui Ding Chuan Cang Jing Jian".

Along with inhalation, left foot steps to the left, slightly wider than shoulders, and the tiptoes face forward; at the same time, swing both arms up with an arch shape to the front of the body, the center of palms facing each other, and the same height as the chest (acupoint Tanzhong) and the same width as the shoulders; look forward (Fig. 4-13). Do not pause, along with breathing, sink both elbows, and withdraw both arms back to the front of the shoulders (children can also place their thumbs at the acupoint Yunmen respectively), the acupoint Laogong is facing one another, with the same height as the acupoint Yunmen. Look forward. (Fig. 4-14)

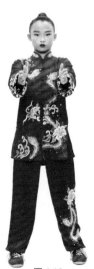

圖 4-13　　　　圖 4-14

第二拍 The second beat

詠唱歌訣 "益氣通陽沖九天"。

隨吸氣，聳肩縮項，繼而在肩胛骨內收擴胸的同時，擡頭向上；眼視後上方，稍停 2 秒。（圖 4-15）

Sing the lyrics "Yi Qi Tong Yang Chong Jiu Tian".

Along with inhalation, shrug the shoulders and shrink the neck, then raise the head up while retracting and expanding the chest with the shoulder blades; look to the upper back, and pause for 2 seconds. (Fig. 4-15)

第三拍 The third beat

詠唱歌訣 "左顧右盼放眼望"。

隨呼氣，兩腿不動；兩掌坐腕前推，與肩同寬，與肩同高，掌心向 前；同時將頭左轉，目視左後方，稍停（圖 4-16）。動作不停，隨吸氣，兩腿仍不動；兩掌下落後撐於髖旁，距離 20 厘米，掌心向後斜向下；同 時，將頭向右轉，眼視右後方，稍停。（圖 4-17）

Sing the lyrics "Zuo Gu You Pan Fang Yan Wang".

Along with exaltation, without moving the legs; sink both wrists with the palms and push them forward, with the same width of the shoulders, same height of the shoulders, and the center of palms facing forward; at the same time, turn the head to the left, look to the top left, pause for a while (Fig. 4-16). Keep moving, along with inhalation, keep the legs still; prop the palms beside the hips after withdrawing them down, 20 cm in distance, with

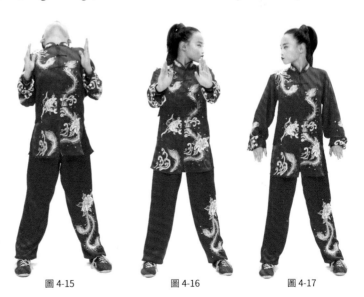

圖 4-15　　　　　圖 4-16　　　　　圖 4-17

the palms obliquely downward; at the same time, turn the head to the right, look to the right back, slightly pause for a while. (Fig. 4-17)

第四拍 The fourth beat

詠唱歌訣 "神形疾患莫可犯"。

隨呼氣，重心右移；兩臂內旋體側擺起至與肩平，繼而外旋使掌心向 上；眼 視 右 掌（圖4-18）。隨 吸 氣，動作不停，左腳向右腳並攏，兩腿相 靠；同時兩臂內合收於頭前，與頭同 高，距離5厘米左右；眼隨右 掌，接 視 前 方 （圖4-19）。隨 呼 氣，身 體 直 起；兩 掌 體 前 下 按，還原於體側；目視前方，成並步站立式。 圖4-18 圖4-19

Sing the lyrics "Shen Xing Ji Huan Mo Ke Fan".

Along with exhalation, the gravity shifts to the right; internally rotate both arms and swing them up to the shoulder level, and then rotate externally to make the center of palms face upward; look at the right palm (Fig. 4-18). Along with inhalation, keep moving, move the left foot next to the right foot and feet together, both legs stand closely together; at the same time, close both arms internally in front of the head, with the same height of the head, at a distance of about 5 cm; the eyes look and follow the right palm, then look forward (Fig. 4-19). Along with exhalation, straighten up the body; press both palms down in front of the body, and return to the side of the body; look forward, stance with feet together. (Fig. 4-18) (Fig. 4-19)

第五拍至第八拍，重復第一拍至第四拍，唯開步轉頭方向相反。做完後，還原成並步站立式。

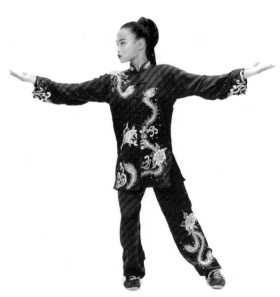

圖4-18

圖4-19

From the fifth to the eighth beat, repeat the first to the fourth beat, except turning the head to a opposite direction when spreading feet. After finishing, revert to stance with feet together.

练习次数 Number of practice

可做 1 ～ 2 個八拍。

Do one to two eight-beat.

练习要领 Practice essentials

(1) 動作柔和緩慢，舒展大方。

(2) 推掌背部後坐，轉頭下頦前探，擡頭不仰體，轉頭固定兩肩。

(3) 呼吸自然深長，思想集中於大椎穴，意綿形舒。

(1) The movement is gentle and slow, comfortable and generous.

(2) Sink and sit to the back when pushing the palms, place the chin slight to the front when turning the head, raise the head without leaning back, fix the shoulders when turning the head.

(3) The breathing is natural and deep, and the thought is concentrated on the acupoint Dazhui, and the mind is soft and smooth.

注意防范 Precautions

(1) 藏頭縮項不充分，肘向後收。

(2) 撐臂轉頸用力突然，且未留勁。

(3) 擡頭仰體，轉頭又轉身。

(1) Not fully withdraw the head and neck, and the elbow withdraws backward.

(2) Sudden force is used when propping the arms and turning the neck, and not keeping some force.

(3) Raise the head and tilt the body, turn both the head and the body.

练习作用 Practice effects

(1) 加強轉頭可牽拉頸背肌肉，預防頸背疾患。藏頭縮項和肩胛骨後收，可活動胸腔，改善胸部血液循環，增強呼吸功能。

(2) 大幅度內收肩胛骨和轉頸，可刺激膏盲穴、大椎穴和定喘穴，預防"五勞七傷"。

(3) 前推後撐兩掌，可起壯力強體、助氣和提振精神的作用。

(1) Strengthening the head rotation can stretch muscles of the neck and back to prevent neck and back diseases. Withdraw the head, neck, and shoulder blades can active the chest cavity, improve blood circulation of the chest, and enhance respiratory function.

(2) Wide range of withdrawing the shoulder blades and turning the neck can stimulate the acupoint Gaomang, Dazhui and Dingchuan to prevent sickness and strain.

 (3) Push forward and prop backward with two palms can strenhthen body, assist breath and boost spirit.

第三式　調理脾胃須單舉
Movement Three Holding One Arm Aloft to Regulate the Functions of the Spleen and Stomach

练习方法 Practice methods

預備式：接前式。

Preparation form: follow the previous movement

第一拍 The first beat

詠唱歌訣"脾胃後天定中原"。

隨吸氣，重心右移，提左踵，身體半面左轉；同時，左臂向左撩至腹前，與腰同高成護腹、護肋式，右臂上提，使右掌尺側貼於章門穴；眼視左前方（圖4-20）。隨呼氣，左腳向左上一大步（4腳左右距離），腳尖向前，不停，後腳踵地蹬伸，使腳尖斜向前45°，重心前移成左弓步；同時，左臂架掌，右掌在左臂上快速穿掌，使右臂置於左腕上；眼視左前方。（圖4-21）

Sing the lyrics "Pi Wei Hou Tian Ding Zhong Yuan".

Along with inhalation, move the center of gravity to the right, raise the left heel, and turn half of the body to the left; at the same time, upper cut the left arm to the left till the front of the belly,

and be the same height as the waist to form a movement of protecting the belly and the ribs. Lift the right arm up so that the ulnar side of the right palm is attached to the acupoint Zhangmen; look at the front left (Fig. 4-20). Along with exhalation, take a big step to the left with left foot (with a distance of 4 feet or so), with the tiptoes facing forward, do not pause, turn the foot and stretch the back foot straightly, so that the tiptoes are obliquely pointing to 45 degrees, move the center of gravity forward to form a left bow stance; at the same time, form a block palm with the left arm, quickly pierce the right palm on the left arm, place the right arm on the left wrist; look at the front left. (Fig. 4-21)

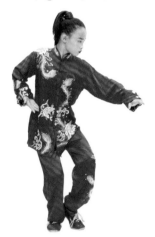
圖 4-20

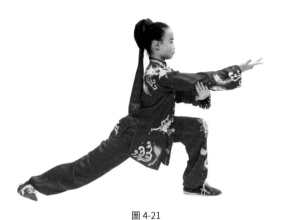
圖 4-21

第二拍 The second beat

詠唱歌訣 "運化水谷血氣全"。

隨吸氣, 左腳內扣, 右腳內擺, 重心後移, 身體回轉成馬步 (弓 步 變馬步);同時, 左掌內扣按於 左腿 (或左髖 10 厘米處), 右臂 內旋, 上撐於頭右側上方, 中指 在肩部投影為肩髃穴 附近, 兩臂 上撐下按形成一個立式 "太極圖";眼視左方。(圖 4-22)

Sing the lyrics "Yun Hua Shui Gu Xue Qi Quan".

Along with inhalation, buckle the left foot inward, swing the right foot inward, shift the center of gravity backward, and turn the body into a horse stance (change the bow stance to a horse stance); at the same time, buckle the left palm inward and press it on the left leg (or 10 cm from the left hipbone), rotate the right

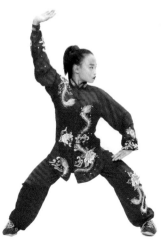
圖 4-22

arm inward and prop it up on the upper right side of the head, the middle finger is projected on the shoulder near the acupoint Jianyu, and both arms are propped up and pressed down to form a vertical "Tai Chi diagram"; look to the left. (Fig. 4-22)

第三拍 The third beat
詠唱歌訣"頂天立地撐與按"。

隨吸氣，重心右移起身，左膝體前提起；同時，左掌上提，右掌下落，兩臂外擺於膝側 45°左右；眼視前方。隨呼氣，兩掌分別迅速拍擊 足三裏穴 和陰陵泉穴；眼視前方。（圖 4-23）

Sing the lyrics "Ding Tian Li Di Cheng Yu An".

Along with inhalation, move the center of gravity to the right and stand up, lift the left knee up in front of the body; at the same time, lift up the left palm, drop the right palm, swing both arms out about 45 degrees on the side; look forward. Along with exhalation, both palms quickly slap the acupoints Zusanli and Yinlingquan respectively; look forward. (Fig. 4-23)

第四拍 The fourth beat
詠唱歌訣"氣血充盈身體健"。

隨呼氣，左腳落地，並於右腳；同時，兩臂 下落置於體側，成並步站立式；眼視前方。

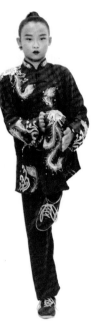

圖 4-23

Sing the lyrics "Qi Xue Chong Ying Shen Ti Jian".

Along with exhalation, the left foot lands on the ground, stand closely together with the right foot; at the same time, the arms are dropped to the side of the body to stance with feet together; look forward.

第五拍至第八拍同第一拍至第四拍，唯動作方向相反。

The fifth to eighth beat are the same as the first to fourth beats, except that the movement directions are opposite.

练习次数 Number of practice
可做 1～2 个八拍。

Do one to two eight-beat.

练习要领 Practice essentials

(1) 舒展大方，快慢相間，動靜結合。

(2) 穿掌迅捷有力，勁達指腹。架掌氣勢恢宏，穩如泰山。提膝拔 頂沈髖，腳趾抓地。

(3) 思想集中，意斂形舒。

(1) Stretching generously, alternating fast and slow speed, combining dynamic and static movements.

(2) Pierce the palm quickly and powerfully, with the force reaching the fingertips. The blocking palm movement is magnificent and stable as Mount Tai. Raise the knee, head up, sink the hips, and grab the ground with the toes.

(3) Concentrated thoughts, convergent and comfortable.

注意防范 Avoidance

(1) 上下肢協調不夠，穿掌、架掌不夠迅捷，勁力不足。

(2) 弓步不穩，蹬伸不足；馬步塌腰跪膝、挺胸腆肚。

(3) 拍擊穴位不準。

(1) Insufficient coordination of the upper and lower limbs, insufficient speed and strength when piercing the palm and blocking the palm.

(2) The bow stance is unstable, and the stretching is insufficient; sink the waist and kneeled down in horse stance, chest and belly out.

(3) Slapping the acupoints inaccurately.

练习作用 Practice effects

(1) 刺激脾胃經，疏泄肝氣；調理脾胃，促進消化吸收。

(2) 提高反應、速度、協調和下肢力量等身體素質。

(3) 培養氣質和勇猛頑強的作風。

(1) Stimulate the spleen and stomach meridians, relieve the Qi in the liver; regulate the spleen and stomach, and promote digestion and absorption.

(2) Improve physical fitness such as reaction, speed, coordination and lower limb strength.

(3) Cultivate temperament, and courageous and tenacious style.

第四式　左右開弓似射雕
Movement Four Posing as an Archer Shooting Both Left- and Right-Handed

练习方法 Practice methods

預備式: 接前式。

Preparation form: follow the previous movement.

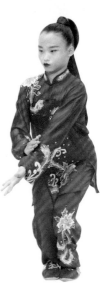

第一拍 The first beat

詠唱歌訣 "肺為相傳"。

配合呼吸，身體半面右轉，左腳振地；同時，左掌向右前方撩出，右 掌拍擊左郄門穴 ；眼視右掌。(圖 4-24)

Sing the lyrics "Fei Wei Xiang Fu".

Cooperate with breathing, turn half of the body to the right, stamp the left foot on the ground; at the same time, upper cut the left palm to the front right, slap the right palm at the left acupoint Ximen; look at the right palm. (Fig. 4-24)

圖 4-24

第二拍 The second beat

詠唱歌訣 "曰華蓋"。

隨吸氣，左腳向左後方撤步，腳尖向左後 方 45°，兩腳之間距離 4 腳左右，繼而右腿 後蹬，重心後移，左腿後弓，成橫襠步；同時，左掌成勾後拉於左肩前，距離 5 厘米左右，右 掌變成八字掌，向右前上方推出，成開弓射雕 勢；眼視右掌食指商陽穴。(圖 4-25)

Sing the lyrics "Yue Hua Gai".

Along with inhalation, withdraw the left foot to the rear left, the tiptoes are 45 degrees to the

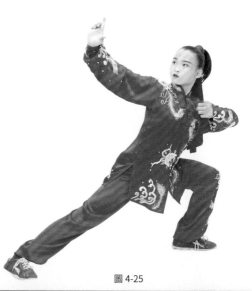

圖 4-25

rear left, the distance between two feet is about 4 feet, then the right leg is stretched and pushed back, move the center of gravity backward, and the left leg is bowed back to form a side bow stance; at the same time, form a hook with the left palm, pull it to the front of the left shoulder, with a distance of about 5 cm, change the right palm to a L-shape palm, push it to the front and upper right side, forming a bow and arching position; look at the acupoint Shangyang of the index finger on the right palm. (Fig. 4-25)

第三拍 The third beat

詠唱歌訣 "主司呼吸"。

隨呼氣, 身體不動; 同時, 左勾變掌外旋後撩, 右八字掌還原變掌外旋, 使兩臂處於同一直線上, 掌心朝上, 與地面夾角為 45°; 眼視左掌商陽穴。
(圖 4-26)

Sing the lyrics "Zhu Si Hu Xi".

Along with exhalation, do not move the body; at the same time, change the left hook to a palm, rotate it externally and upper cutting it backward, revert the right L-shape palm to a palm and rotate it externally, so that the arms are on the same straight line with the center of palms facing up, and is the angle of 45 degrees with the ground; look at the acupoint Shangyang on the left palm. (Fig. 4-26)

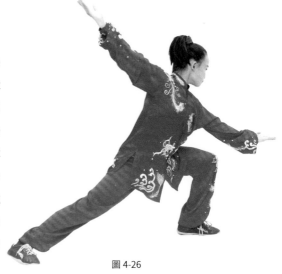

圖 4-26

第四拍 The fourth beat

詠唱歌訣 "朝百脈"。

隨吸氣, 重心前移, 身體轉正, 左腳向右腳並攏微蹲; 同時兩臂弧形 上擺合於面前; 兩手與頭同高, 距離 5 厘米; 眼視前方 (圖 4-27)。隨呼氣, 身體起立; 兩掌下按於腹前, 眼視右前方繼而下落置於體側, 成並步站立式; 眼視前方。(圖 4-28)

Sing the lyrics "Chao Bai Mai".

Along with inhalation, move the center of gravity forward, turn the body back to normal

position, move the left foot closely with the right foot, slightly squat down; at the same time, swing both arms up with an arc shape in front of the body; both hands are at the same height as the head, with a distance of 5 cm; look forward (Fig. 4-27). Along with exhalation, upright the body; press the two palms down in front of the belly, look at the right front, drop them down on the side of the body, forming a spread feet stance standing posture; look forward. (Fig. 4-28)

第五拍至第八拍同第一拍至第四拍，唯動作方向相反，且第五拍、第六拍詠唱歌訣"彎弓射箭勤學練"；

第七拍至第八拍詠唱歌訣"豪氣雄姿育英才"。

The fifth to eighth beats are the same as the first to fourth beats, except that the directions of the movements are opposite, and the lyrics of the fifth and sixth beats is "Wan Gong She Jian Qin Xue Lian", while the lyrics of the seventh to eighth beats is "Hao Qi Xiong Zi Yu Ying Cai".

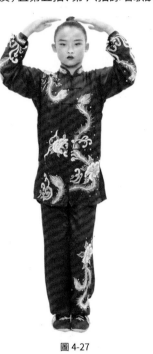

圖 4-27　　　　　　　圖 4-28

练习次数 Number of practice

可做 1 ～ 2 個八拍。

Do one to two eight-beat.

练习要领 Practice essentials

（1）動靜結合，快慢相間，振腳與對掌拍擊同步進行，幹脆利落。

（2）開弓前推弧形推出，需沈肩墜肘，豎指舒指。拉弓向後需壓肘扣指。

（3）橫襠步下蹲，要沈髖傾身，身體斜中正，專註射雕姿勢。

(1) A combination of dynamic and static movements, alternating fast and slow speed, stamp the feet and slap the palm simultaneously, simply and neatly.

(2) Push the palm forward with an arch shape, sink the shoulders and drop the elbows, lift the fingers and relax them. Press the elbows and buckle the fingers with forming the arch posture.

(3) Squat in the side bow stance, leaning and sink the hipbones, the body is obliquely centered, focus on the arching posture.

注意防范 Avoidance

(1) 上肢下協調不夠，動作軟塌，拖泥帶水，勁力不足。

(2) 射雕坐腕、壓肘不實，力滯肘部。

(3) 橫襠步，沈髖不夠，姿勢不穩。

(1) Insufficient coordination of upper and lower limbs, soft and sluggish movements, with insufficient strength.

(2) Sink the wrist when arching, press the elbow with insufficient strength, and the strength is lagging behind the elbow.

(3) Insufficient sinking with the hipbones and unstable posture in side bow stance.

練習作用 Practice effects

(1) 刺激商陽穴、肘部，暢通心肺經，改善肺功能。

(2) 展肩擴胸，改善胸部血液循環，改善肺功能。

(3) 增加前臂和手指力量，提高腕關節和指關節的靈活性；發展下肢 肌肉力量，提高平衡和協調能力。

(4) 培養英雄氣概，提升正能量，激發愛國熱情。

(1) Stimulate the acupoint Shangyang and elbow, unblock the heart and lung meridians, and improve lung function.

(2) Expand the shoulders and the chest, improve blood circulation in the chest, and improve lung function.

(3) Increase the strength of the forearm and fingers, improve the flexibility of the wrist and finger joints; develop the muscle strength of the lower limbs, and improve balance and coordination ability.

(4) Cultivate heroism, enhance positive energy, and stimulate patriotic enthusiasm.

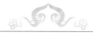

第五式　搖頭擺尾去心火
Movement Four Posing as an Archer Shooting Both Left- and Right-Handed

练习方法 Practice methods

預備式：接前式。

Preparation form: follow the previous movements.

第一拍 The first beat

詠唱歌訣 "心為君主地位尊"。

隨吸氣，左腳向左開步提踵，距 離 3 腳左右，腳尖向前；同時，兩掌 腹前疊掌（圖 4-29），接上提卷指（三折）、彈甲、分掌、外撐於體側，與肩同高，掌心朝側，眼視前方（圖 4-30）。隨呼氣，口吐 "嘿" 音，落踵振腳下蹲成馬步；同時，兩掌勞 宮穴迅速分別叩擊環跳穴；眼視前方。（圖 4-31）

Sing the lyrics "Xin Wei Jun Zhu Di Wei Zun" .

Along with inhalation, move the left foot to the left and raise heels, with a distance of about 3 feet, and the tiptoes face forward; at the same time, fold both palms in front of belly (Fig. 4-29), then curl the fingers (three folds), snap the nails, separate the palms and prop them up on the

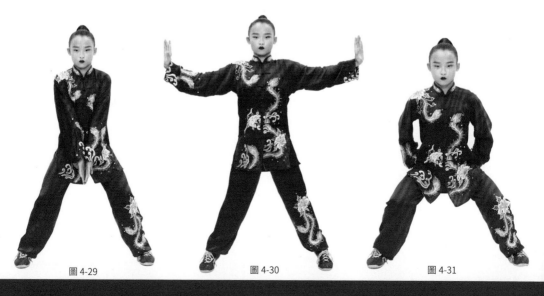

圖 4-29　　　　　　圖 4-30　　　　　　圖 4-31

side of the body, with the same height of the shoulder, the center of palms facing sideways, look forward (Fig. 4-30). Along with exhalation, exhale the sound of "hei", squat into a horse stance with falling the heels and stamp the feet; at the same time, quickly tap the acupoint Huantiao with the acupoint Laogong on both palms respectively; look forward. (Fig. 4-31)

第二拍 The second beat

詠唱歌訣 "統領五臟益血神"。

隨吸氣，身體起立，兩踵上提；同時，兩臂外旋，體側外擺至與肩平，掌心朝上；眼視前方（圖 4-32）。隨呼氣，口吐 "哈" 音，落踵振腳，屈 膝成馬步；同時，兩掌分別迅速拍打大腿內側（中部），眼視前方。（圖 4-33）

Sing the lyrics "Tong Ling Wu Zang Yi Xue Shen".

Along with inhalation, upright the body, raise both heels; at the same time, rotate both arms externally, swing them out to the side of the body so that they reach the shoulder level, the center of palms facing up; look forward (Fig. 4-32). Along with exhalation, exhale a "ha" sound, drop the heels and stamp the feet, bend the knees into horse stance. At the same time, quickly slap the inner thighs (middle position) with both hands respectively, look forward. (Fig. 4-33)

第三拍 The third beat

詠唱歌訣 "搖頭擺尾融心腎"。

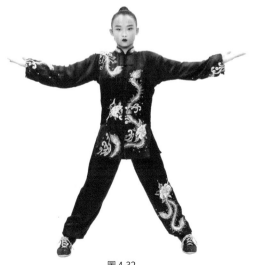
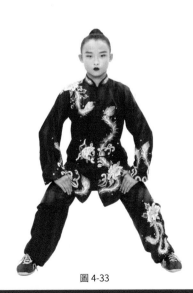

圖 4-32

圖 4-33

隨吸氣，馬步不動；同時，兩掌撐 於腿部內側中部，上體先向左盡量側傾；眼視前方（圖 4-34）。繼而，身體前俯 回移經體前、體右側前方後移，再回正；眼視前下方。（圖 4-35、圖 4-36）

Sing the lyrics "Yao Tou Bai Wei Rong Xin Shen".

Along with inhalation, remain the horse stance unchanged; at the same time, prop both palms in the inner middle side of the legs, the upper body should first lean to the left as far as possible; look forward (Fig. 4-34). Then, the body bends forward, then moves backward through the front of the body and the right side of the body, and then moves to a normal position; look at front bottom. (Fig. 4-35, Fig. 4-36)

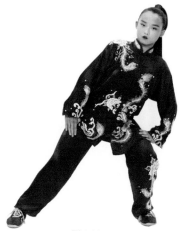

圖 4-34

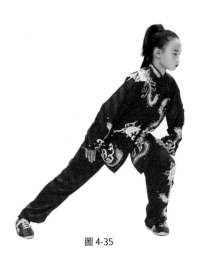

圖 4-35

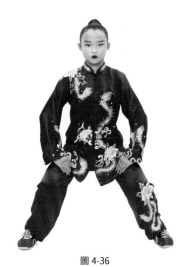

圖 4-36

第四拍 The fourth beat

詠唱歌訣 "水火相濟 寧身心"。

隨吸氣，重心右移；同時，兩掌體前上托，經面前翻掌外分撐於體側，與肩同高，掌心朝側；眼 視前方（圖 4-37）。繼而，左腳向右腳並攏起立；兩 掌體側下按置於腿側，成 並步站立式；眼視前方。

Sing the lyrics "Shui Huo Xiang ji Ning Shen Xin".

Along with inhalation, the center of gravity shifts to the right; at the same time, both palms are lifted up in front of the body, flip the palms in front of the body and prop them on the side of the

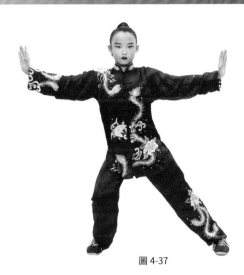

圖 4-37

body separately, with the same height of the shoulder, the center of palms facing the sides; look forward (Fig. 4-37). Then, move the left foot together with the right foot and stand up; press the palms beside the body till the sides of the legs to form a spread feet stance standing posture; look forward.

第五拍至第八拍同第一拍至第四 拍，唯動作方向相反。做完後，兩腳並 攏站立；兩掌依次卷指握拳，抱於腰間；眼視前方。（圖 4-38）

The fifth to eighth beats are the same as the first to fourth beats, except that the movement directions are opposite. After finishing, stand with the feet closely together; roll the fingers in turn with both palms to form fists, hold them beside the waist; look forward. (Fig. 4-38)

练习次数 Number of practice

可做 1 ～ 2 個八拍。

Can Do one to two eight-beat.

圖 4-38

练习要领 Practice essentials

（1）動靜結合，快慢相間，振腳與 拍擊同步進行，迅捷有力，幹脆利落。

（2）馬步下蹲要穩，身體移動畫圈 時幅度宜大，還要固定髖和膝。

（3）叩擊環跳時，可發 "嘿" 聲，叩擊大腿內側中部時，可發 "哈" 音。

(1) Combination of dynamic and static movements, alternating fast and slow speed, stamp the

85

feet and slap simultaneously, swiftly and powerfully, simply and neatly.

(2) The horse stance should be squat steadily, the range of body movements should be wide when encircling, and the hips and knees should be fixed.

(3) When tapping the acupoint Huantiao, make a "hei" sound; when tapping the middle of the inner thigh, make a "ha" sound.

注意防范 Avoidance

（1）動作拖泥帶水，且振腳、拍擊和發聲不一致。

（2）叩擊穴位不準，勁力不足。

（3）馬步跪膝、塌腰；晃身哈腰，且膝、髖未固定。

(1) The action is sluggish, and the stamping feet, tapping and vocalization are inconsistent.

(2) Inaccurate tapping on acupoints and with insufficient strength.

(3) Kneeling and collapsed waist in horse stance; swaying the body and bowing, and knees and hips are not fixed.

練習作用 Practice effects

（1）刺激督脈，強壯腰腿，調補腎水，平抑心火。

（2）暢通督脈和全身氣血，預防坐骨神經痛。

（3）壯中補元，激發豪情。

(1) Stimulate the Du meridian, strengthen the waist and legs, regulate and invigorate the kidney water, and calm the heart fire.

(2) Unblock the Du meridian and the Qi and blood throughout the body to prevent sciatica.

(3) Zhuangzhong buyuan and stimulates pride.

第六式　攢拳怒目增氣力
Movement Six　Thrusting the Fists and Making the Eyes Glare to Enhance Strength

练习方法 Practice methods

預備式：接前式。

Preparation form: follow the previous movement

第一拍 The first beat

詠唱歌訣 "肝為將軍"。

隨吸氣，左腳向左開步，距離約 3 腳，腳尖向前；同時，兩臂內旋側擺接外旋至與肩平，掌心向後；眼視左掌（圖 4-39）。繼而，下蹲成馬步；同時，隨擰腰轉體使身體右轉，帶動左臂前擺至胸前，右臂回收，依次卷指握拳抱於腰側；眼隨左掌。（圖 4-40）

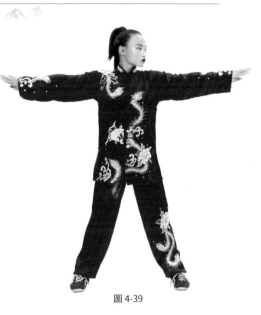

圖 4-39

Sing the lyrics "Gan Wei Jiang Jun".

Along with inhalation, move the left foot to the left, with a distance of about 3 feet, and the tiptoes facing forward; at the same time, rotate both arms inward and side-swing them, then rotate them outward till they reach the shoulder level, the center of palms facing backward; look at the left palm (Fig. 4-39). Then, squat into a horse stance; at the same time, twist the waist to turn the body to the right, swing the left arm forward to the chest, withdraw the right arm, roll the fingers in turn to form a fist, hold the fist beside the waist; with eyes following the left palm. (Fig. 4-40)

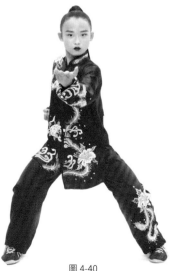

圖 4-40

第二拍 The second beat

詠唱歌訣 "腎同源"。

隨呼氣，下蹲馬步不動，固定 髖、膝；隨著 "哈" 音的發出，擰 腰順肩。將右拳沖出，掌心向下，拳面朝前，同時，左掌依次卷指握 拳，快速收回腰間，拳心朝上；怒 目瞪視前方（圖 4-41）。動作不停，隨著 "哈" 音的發出，擰腰順肩，將左拳沖出，同時，右掌握拳收於 腰間；怒目瞪視前方。（圖 4-42）

Sing the lyrics "Shen Tong Yuan" .

Along with exhalation, squat down with the horse stance remains unchanged. Fix the hips and knees; follow with the "ha" sound, twist the waist and shoulders accordingly. Punch the right fist forward, with the center of palm facing down, and the face of the fist facing forward, and at the same time, roll the left palm in turn to form a fist, quickly withdraw it to the side of the waist with the center of fist facing up; staring at the front angrily (Fig. 4-41). Do not pause, follow with the sound of "ha", twist the waist and shoulders accordingly, punch the left fist forward, at the same time, withdraw the right fist to the side of the waist; staring at the front angrily. (Fig. 4-42)

第三拍 The third beat

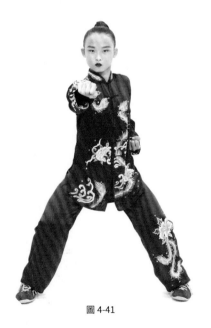 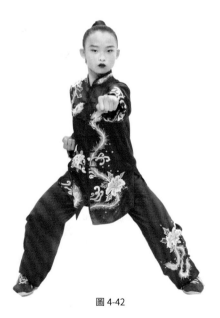

圖 4-41　　　　　　　　圖 4-42

詠唱歌訣 "主筋通目"。

隨吸氣，重心右移；兩拳變掌，兩臂經體側內旋外擺，接外旋上擺至 與肩平，掌心朝上；眼視右掌 （圖4-43）。繼而，左腳向右腳並攏微蹲；同時，兩掌內合於頭前，掌心向下，掌距頭約 10 厘米，掌指之間距離約 10 厘米；眼視前方。（圖4-44）

Sing the lyrics "Zhu Jin Tong Mu".

Along with inhalation, the center of gravity shifts to the right; change both fists to palms, rotate both arms inward and swing them outward through the side of the body, and then swing them upward until they are level with the shoulders, the center of palms facing upward; look at the right palm (Fig. 4-43). Then, move the left foot to the right foot and squat slightly; at the same time, fold both palms in front of the head, the center of palms facing downward, the palms are about 10 cm away from the head, and the distance between the palms and fingers is about 10 cm; look forward. (Fig. 4-44)

第四拍 The fourth beat

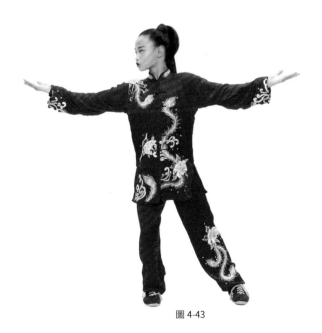

圖 4-43

圖 4-44

詠唱歌訣 "智勇全"。

隨呼氣, 兩腿緩緩伸直; 兩掌面前下按置於體側, 繼而依次卷指握拳, 抱於腰間; 眼視前方。(圖 4-45)

Sing the lyrics "Zhi Yong Quan".

Along with exhalation, straighten both legs slowly; press both palms downward in front of the body and place them on the side of the body, then roll the fingers and form fists in turn, hold them beside the waist; look forward. (Fig. 4-45)

第五拍至第八拍, 重復第一拍至第四拍, 唯動作方向相反, 且第五拍、第六拍 詠唱歌訣 "怒目沖拳吼聲震"; 第七拍、第八拍詠唱歌訣 "武穆精神永流傳"。做 完後, 兩掌垂落體側, 成並步站立式, 眼 視前方。

For the fifth to eighth beats, repeat the first to fourth beats, except that the movements are in the opposite directions, and lyrics of the fifth and sixth beats is "Nu Mu Chong Quan Hou Sheng Zhen"; and the lyrics of the seventh and eighth beats is " Wu Mu Jing Shen Yong Liu Chuan". After finishing, drop both palms down on the side and stance with feet together, look forward.

圖 4-45

练习次数 Number of practice
可做 1 ~ 2 個八拍。

one to two eight-beat.

练习要领 Practice essentials
(1) 動靜結合, 快慢相間, 幹脆利落。

(2) 沖拳時怒目圓睜, 腳趾抓地, 力 達拳面, 沖拳和 "哈" 聲同步, 力貫拳面。 拳變掌之前, 中沖穴要瞬間點扣勞宮穴。

(3) 馬步下蹲要固定髖膝, 以後肘帶 腰, 充分擰腰順肩。

(1) Combination of dynamic and static movements, alternating fast and slow speed, simply and neatly.

(2) When punching the fist, look forward angrily, the tiptoes grip the ground, the force reaches the face of the fist. The punching fist is synchronized with the "ha" sound, with the force reaches

the face of the fist. Before changing the fist to a palm, Zhongchong acupoints buckle Laogong acupoints instantaneously.

(3) Fix the hips and knees when squatting, use the back elbow to bring along the waist, twist the waist and shoulders fully.

注意防范 Avoidance

(1) 动作拖泥带水，软弱无力。

(2) 冲拳，耸肩掀肘，腰松膝跪，发力分散。

(3) 精神涣散，气势不高。

(1) The action is sluggish and weak, with any force.

(2) Shrug the shoulders and lift the elbows when punching the fists, kneel down with loose waist and the force is disperse.

(3) The spirit is slack and the momentum is not high.

练习作用 Practice effects

(1) 疏泄肝火，疏肝利胆。

(2) 固肾壮腰，提高上下肢力量。

(3) 培育正气，激发爱国热情。

(1) Soothing liver and promoting gallbladder.

(2) Strengthen the kidney and waist, improve the strength of upper and lower limbs.

(3) Cultivate righteousness and stimulate patriotic enthusiasm.

第七式　雙手攀足固腎腰
Movement Seven　Touching the Feet to Strengthen the Kidneys

练习方法 Practice methods

預備式：接前式。

Preparation form: follow the previous movement

第一拍　The first beat

詠唱歌訣 "腎為先天戍邊軍"。

隨吸氣，微低頭，挺膝、挺髖、挺腹、挺胸擡頭，使身體成為一個 反弓形；同時，兩肩胛骨內收，兩臂外旋於體側，髖後 45°；眼視後上方 （圖 4-46）。繼而，身體直起；兩臂經體後向前上擺至頭頂，與肩同寬，掌心向前；眼視前方（圖 4-47）。隨呼氣，兩腿直立，上體前俯 45°；同時，兩臂經體前擺至體後髖旁 45°，眼視前下方；繼而，兩掌握拳，用拳背分別叩擊兩腎俞穴；眼視前下方。（圖 4-48）

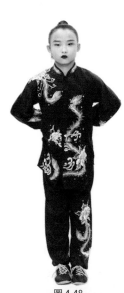

圖 4-46　　　　　　　　　　圖 4-47　　　　　　　　　　圖 4-48

Sing the lyrics "Shen Wei Xian Tian Shu Bian Jun".

Along with inhalation, lower the head slightly, raise the knees,hips, belly, and chest, chest out and raise the head so that the body form a reversed arch posture; at the same time, withdraw the shoulder blades, rotate both arms outward to the side of the body, with 45 degrees behind the hips; look to the upper back. (Fig. 4-46). Then, straighten the body; swing the arms forward and upward to the top of the head through the body, with the same height of the shoulder, the center of palms facing forward; look forward (Fig. 4-47). Along with exhalation, straighten both legs and bend the upper body 45 degrees forward; at the same time, swing both arms forward to 45 degrees beside the hips through the front of the body, look to the front bottom; then, hold fists with both palms, use the back of the fists to tap the two acupoints Shenyu respectively; look to the front bottom. (Fig. 4-48)

第二拍 The second beat

詠唱歌訣 "主骨生髓藏精魂"。

隨吸氣，兩拳變掌，稍上提撫背；眼視前下方。不停，隨呼氣，身 體前俯；同時，兩掌經背腰臀及腿後外側向下按摩至腳跟，繼而抱住腳 踝，前臂貼小腿；眼視前下方（圖 4-49）。繼而，中沖穴點摳太溪穴，兩臂用力抱腿，幫助挺膝、壓髖、低頭，將胸、腹、頭貼於大小腿。

Sing the lyrics "Zhu Gu Sheng Sui Cang Jing Hun".

Along with inhalation, change both fists to palms, lift the back slightly; look to the front bottom. Do not pause, along with exhalation, bend forward; at the same time, massage down to the heels with both palms through the back, waist, hip and the posterolateral of the legs, then hold the ankles and attach the forearms to the calves; look to the front bottom (Fig. 4-49). Then,

圖 4-49

tap the acupoint Taixi with the acupoint Zhongchong, hold the legs with both arms forcefully, help lifting the knees, pressing the hips, and lowering the head, attach the chest, belly, and head to the legs.

第三拍 The third beat

詠唱歌訣 "俯身攀足頻蹲起"。

隨吸氣，兩臂放鬆，兩掌上提按於兩膝，勞宮穴對準鶴頂穴，身體稍 起；眼視前下方（圖 4-50）。隨

呼氣，沈髖墜臀全蹲；同時兩掌勞宮穴同時撚揉
鶴頂穴，撫於兩膝；眼視前方。（圖 4-51）
Sing the lyrics "Fu Shen Pan Zu Pin Dun Qi".
Along with inhalation, relax both arms, lift the
palms and press them on the knees, align the
Laogong acupoints with the acupoint Heding,
raise the body slightly; look to the front
bottom (Fig. 4-50). Along with exhalation,
sink the hipbones and hip, squat down fully;
at the same time, rub the Heding acupoint
with both palms at the same time, rubbing

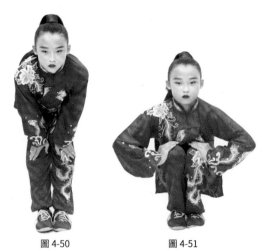

圖 4-50　　　　　圖 4-51

the Heding acupoints with the Laogong acupoints of both palms at the same time; look forward.
(Fig. 4-51)

第四拍 The fourth beat

詠唱歌訣 "強骨增力智常新"。

隨吸氣，兩腿直起，身體稍起；兩掌向上摩運腿前；眼視前下方。隨 呼氣，身體直起；兩掌分別置於腿側，
成並步站立式；眼視前方。（圖 4-52）

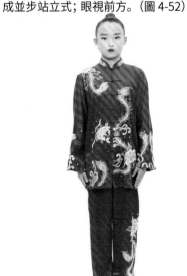

圖 4-52

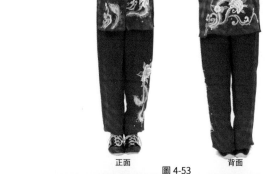

正面　　圖 4-53　　背面

Sing the lyrics "Qiang Gu Zeng Li Zhi Chang Xin".

Along with inhalation, straighten both legs and lift the body slightly; slide both palms up to the front of the legs; look to the front bottom. Along with exhalation, straighten the body; place both palms to the sides of the legs, stance with feet together; look forward. (Fig. 4-52)

第五拍至第八拍同第一拍至第四拍。做完後，並步站立；兩臂背後上提，兩掌分別置於腎俞穴；眼視前 方。（圖 4-53）

The fifth to eighth beat are the same as the first to fourth beat. After finishing, stand with both feet closely together; raise the arms at the back of the body, place both palms on the acupoints Shenshu respectively; look forward. (Fig. 4-53)

练习次数 Number of practice

重復第一拍至第四拍 3～4 次。

Repeat the first to the fourth beat three to four times.

练习要领 Practice essentials

（1）挺膝、挺髖、挺腹、挺胸依次完成，幅度宜大。

（2）俯身攀足，循序漸進，量力而行，不得屈膝。

（3）按膝全蹲，不提腳跟，摩運要一摩 "三經" 適當用力。

(1) The knees, hips, belly, and chest should be raised in sequence and in wide range.

(2) Lean over and climb movement should be proceed step by step, do not over estimate self-ability, and don't bend the knees.

(3) Fully squat on the knees without lifting the heels, rubbing the "three sutras" with appropriate force when sliding the palms up.

注意防范 Avoidance

（1）脊柱蠕動幅度不足。

（2）抱腿俯身腰臀松懈，兩膝彎曲。

（3）俯身攀足追求幅度過大。

(1) Insufficient range of movements in spine peristalsis.

(2) The waist and hips are loose when holding the legs and leaning the body, with both knees bent.

(3) Leaning over and climbing too much in pursuit.

练习作用 Practice effects

（1）牽拉膀胱經，蠕動任督二脈，刺激太溪。

（2）固腎壯腰，增強腿部力量。

（3）改善智力，發展軀幹前後肌群的力量與脊柱的靈活性，達到固腎壯腰的目的。

(1) Pull the bladder meridian, squirm the Ren and Du meridian and stimulate the acupoint Taixi.

(2) Strengthen the kidney and waist, enhance the strength of the legs.

(3) Improve intelligence, develop the strength of the muscles of the whole body and the flexibility of the spine, so as to achieve the purpose of strengthening the kidney and waist.

第八式　背後七顛百病消
Movement Eight Moving the Hands down the Back and legs, and Raising and Lowering the Heels to Cure Diseases

练习方法 Practice methods

預備式：接前式。

Preparation form: follow the previous movement

第一拍 The first beat

詠唱歌訣 "經絡處處通身心"。

隨吸氣，腳跟提起至最高點；稍停，眼視前方（圖 4-54）。隨呼氣，連續顛足 3 次，繼而，振腳落地；眼視前方。（圖 4-55）

Sing the lyrics "Jing Luo Chu Chu Tong Shen Xin".

Along with inhalation, lift the heels to the highest point; pause for a while and look forward (Fig. 4-54). Along with exhalation,lifting the heels continuously for three times, then stamp the feet to the ground; look forward. (Fig. 4-55)

第二拍 **The second beat**

詠唱歌訣 "運送氣血濡形神"。

隨吸氣，腳跟提起至最高點；稍停，眼視前方（圖 4-56）。隨呼氣，連續顛足 3 次，繼而振腳落地；眼視前方。（圖 4-57）

Sing the lyrics "Yun Song Qi Xue Ru Xing Shen".

Along with inhalation, lift the heels to the highest point; pause for a while and look forward (Fig.

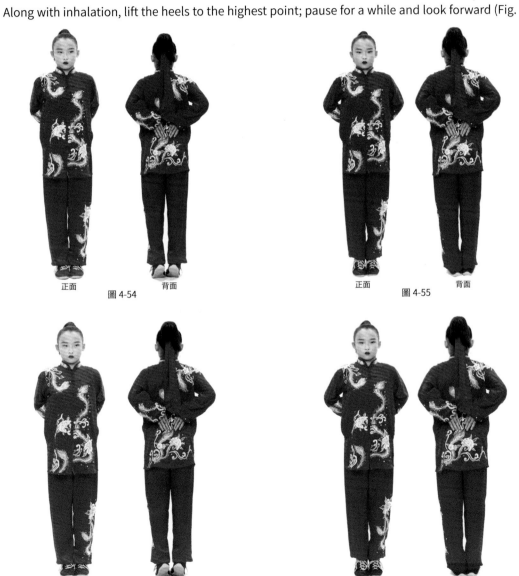

正面　　　　　　　背面　　　　　　　　　　　　正面　　　　　　　背面
　　　　圖 4-54　　　　　　　　　　　　　　　圖 4-55

正面　　　　　　　背面　　　　　　　　　　　　正面　　　　　　　背面
　　　　圖 4-56　　　　　　　　　　　　　　　圖 4-57

4-56). Along with exhalation, lifting the heels continuously for three times, then stamp the feet to the ground; look forward. (Fig. 4-57)

第三拍 The third beat

詠唱歌訣 "提踵顛足調百脈"。

隨吸氣，腳跟提起至最高點；稍停，眼視前方（圖 4-58）。隨呼氣，連續顛足三次，繼而振腳落地；眼視前方。（圖 4-59）

Sing the lyrics "Ti Zhong Dian Zu Tiao Bai Mai".

Along with inhalation, lift the heels to the highest point; pause for a while and look forward (Fig. 4-58). Along with exhalation, lifting the heels continuously for three times, then stamp the feet to the ground; look forward. (Fig. 4-59)

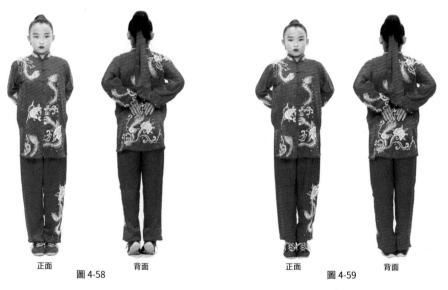

正面　　　　背面　　　　　　　正面　　　　背面
　　　　圖 4-58　　　　　　　　　　圖 4-59

第四拍 The fourth beat

詠唱歌訣 "根深葉茂煥青春"。

隨吸氣，腳跟提起至最高點；稍停，眼視前方（圖 4-60）。隨呼氣，連續顛足 3 次，繼而振腳落地；眼視前方。（圖 4-61）

Sing the lyrics "Gen Shen Ye Mao Huan Qing Chun".

Along with inhalation, lift the heels to the highest point; pause for a while and look forward (Fig. 4-60). Along with exhalation, lifting the heels continuously for three times, then stamp the feet to the ground; look forward. (Fig. 4-61)

正面　　　　　背面　　　　　　　　　正面　　　　　背面

圖 4-60　　　　　　　　　　　圖 4-61

第五拍至第七拍與前四拍相同，但不用顛足、直接振腳落地 3 次。做 完後，兩掌下落垂於體側，成並步站立式；眼視前方。

The fifth to seventh beats are the same as the first four beats, but do not need to lift the heels, just stamp the feet to the ground for three times. After finishing, drop both palms to the side of the body to the stance with feet together; look forward.

练习次数 Number of practice

共振腳 7 次。

Stamp feet in total seven times.

练习要领 Practice essentials

（1）上提時要腳趾抓地，兩腳跟並攏，百會穴領先。

（2）腳跟落地時，震地力量適度，同時，沈肩松肘，虛腋舒胸。

（3）振腳後，要稍停片刻，體會從頭到腳的全身暢快淋漓之感。

(1) Grasp the ground with the tiptoes when uplifting, place both heels closely together, and take the lead at the acupoint Baihui.

(2) When the heels fall on the ground, the strength of stamping the ground is moderate, and at the same time, sink the shoulders and loose the elbows, leave spaces between the armpits and the body, relax the chest.

(3) After stamping the feet, pause for a while, experience the invigorating feeling of the whole body from the head to toes.

注意防范 Avoidance

（1）上提時端肩、夾肘。

（2）註意力集中在腳踵用力，身體重心不穩。

(1) Shrug the shoulders and clamp the elbows when lifting.

(2) Focused on using the force on the heels, and the center of gravity is unstable.

练习作用 Practice effects

（1）震動全身，放松全身上下，暢通全身氣血。

（2）刺激足底反射區，改善生殖泌尿系統功能。

（3）發展小腿後群肌力，提高人體的平衡能力，消除疲勞。

（4）體驗根深葉茂、茁壯成長之感。

(1) Vibrate the whole body, relax the whole body, and unblock the blood of the Qi and whole body.

(2) Stimulate the plantar reflex area and improve the function of the genitourinary system.

(3) Develop muscle strength of the back of the calf, improve the body's balance ability, and eliminate fatigue.

(4) Experience the feeling of deep-rooted and lush growth.

收 勢　Closing Form

练习方法 Practice methods

預備式：接前式。

詠唱歌訣 "練習到此結束"。

Preparation form: follow the previous form
Sing the lyrics "Lian Xi Dao Ci Jie Shu" .

圖 4-62

第一拍 The first beat

隨吸氣，兩臂內旋向兩側 擺起，與髖同高，掌心向後
斜 向上；目視前方。（圖 4-62）詠唱歌訣 "望大家努
力 學習"。

Along with inhalation, rotate both arms inward and
swing them to both sides, with the same height of
the hips, the center of palms facing the inclined
top of the back; look forward. (Fig. 4-62) Sing the
lyrics "Wang Da Jia Nu Li Xue Xi".

第二拍 The second beat

隨呼氣，兩臂屈肘，兩掌 內合，兩掌相疊於腹部（男生 左手在裏，女生右手在裏），勞 宮 對 準 丹 田；
眼 視 前 方。（圖 4-63）詠唱歌訣 "堅持鍛煉、身體健康、為國添光"！

Along with exhalation, bend the elbows with both arms, hold the palms inward together, overlap
them on the belly (boys with left hand inward, girls with right hand inward), the acupoint Laogong
is aligned with the Dantian; look forward. (Fig. 4-63) Sing the lyrics "Jian Chi Duan Lian, Shen Ti
Jian Kang, Wei Guo Tian Guang"!

第三拍 The third beat

兩臂下落，兩掌垂於體側。

Drop both arms, place both palms beside the body.

第四拍 The fourth beat

身體微前傾，兩掌腹前擊掌；眼視兩掌。接著起 身落掌成並步站立式；眼視前方結束。

Lean the body forward slightly, clap the palms in front of the belly; look at both palms. Then, upright the body and drop the palms to the stance with feet together; look forward and end.

練習次数 Number of practice

第一拍到第四拍，共１次。

From the first beat to the fourth beat,once in total.

圖 4-63

練習要领 Practice essentials

（1）旋臂充分，柔緩圓勻，舒展大方，找準穴位。

（2）呼吸悠勻細緩，自然流暢。

（3）思想集中，怡然自得。

(1) Rotate the arms fully. gently, slowly, round and even, stretch generously, and pinpoint acupoints accurately.

(2) Gentle, smooth, and natural breathing.

(3) Concentration of thought and self-satisfaction.

注意防范 Avoidance

（1）擺臂聳肩提肘，動作忽快忽慢。

（2）呼吸急促，註意力渙散。

(1) Swing arms, shrug shoulders and raise elbows, and the movements are sometimes fast and sometimes slow.

(2) Shortness of breath and loss of concentration.

练习作用 Practice effects

（1）放松身心，調勻呼吸，平靜情緒。

（2）壯中補元。

(1) Relax the body and mind, breath evenly, and calm the emotions.

(2) Zhuangzhong buyuan.

注意事项:

1. 嚴肅認真，精神飽滿，充滿喜悅。

2. 場上不奔跑打鬧，聽從指揮，秩序井然。

3. 著裝整潔，適當寬松。

4. 練習前不憋大小便，練習中不帶不良情緒。

5. 練習前後稍做準備和整理練習。

6. 練習前後要洗手。

7. 先天性心臟病和癲癇病患者忌練。

Notes:

1. Be serious, full of energy, and full of joy.

2. Do not run and fight on the court, obey the command, and be in order.

3. Dress neatly and appropriately, with slightly loose customs.

4. Do not hold back the urine and bowels before practice, and do not bring bad emotions during practice.

5. Prepare and organize the exercises before and after practicing.

6. Wash the hands before and after practicing.

7. Patients with congenital heart disease and epilepsy should avoid practicing.

總 編 輯：冷先鋒
責任印製：冷修寧
版面設計：明栩成

Ba Duan Jin for Children（《少兒八段錦》）；By Xiaofei Hu et al.（胡曉飛 等 編著）.
Copyright © 2021 Beijing Sport University Press Co., Ltd
（©2021 北京體育大學出版社有限公司）.
Traditional Chinese — English Version Published by Hong Kong International Wushu
Association with authorization from Beijing Sport University Press Company Limited
（本书中文繁體—英文版由北京體育大學出版社有限公司授權香港國際武術總會有限公司出版發行）.

香港國際武術總會有限公司 出版
香港聯合書刊物流有限公司 發行
代理商：臺灣白象文化事業有限公司
書號：ISBN 978-988-75077-8-9
香港地址：香港九龍彌敦道 525 -543 號寶寧大廈 C 座 412 室
電話：00852-95889723 \ 91267932
深圳地址：深圳市羅湖區紅嶺 2118 號建設集團大廈 B 座 20 樓 A 室
電話：0755-25950376\13352912626
臺灣地址：401 臺中市東區和平街 228 巷 44 號
電話：04-22208589
印次：2021 年 9 月第一次印刷
印數：5000 冊
網　　址：http://hkiwa.com
Email: hkiwa2021@gmail.com